The Duchess of Beaufort's Flowers

GLORIA COTTESLOE and DORIS HUNT

Foreword by the Duke of Beaufort

Webb&Bower

EXETER, ENGLAND

First published in Great Britain 1983 by
Webb & Bower (Publishers) Limited
9 Colleton Crescent, Exeter, Devon EX2 4BY

Designed by Malcolm Couch

Plates photographed by Michael S. Alexander

British Library Cataloguing in Publication Data

Cottesloe, Gloria
 The Duchess of Beaufort's flowers.
 1. Kychicus, Everhardus 2. Frankcom, Daniel
 3. Flowers in art
 I. Title II. Hunt, Doris
 758'.42'0942 ND1403.G74

ISBN 0–906671–71–X

Typeset in Great Britain by August Filmsetting,
Warrington, Cheshire

Printed and bound in Hong Kong by Mandarin Offset International Limited

LIST OF ILLUSTRATIONS

For Flora Fremantle

FOREWORD

Henry Somerset, 10th Duke of Beaufort

The collection of flower paintings that are the subject of this book have always been familiar to me, and it is my pleasure to share them now with a wider public than those who have enjoyed them at Badminton. I firmly believe that things of beauty should be seen and shared as much as possible, and with this principle in mind I have always welcomed the opportunity to entertain large numbers of people at Badminton – though I imagine there are not many hosts who have a quarter of a million people at a time tramping round their grounds as I do each April for the Horse Trials! We open the House to the public on certain days during the summer months, and my wife and I are happy to lend it sometimes for dances and other activities arranged to raise money for causes which we support.

Flowers have always played an important part in the lives of the people who have lived in this house – and there have been thirteen generations of Somersets – and, although we can no longer employ a head gardener with eighteen men working under him as in the halcyon days of my childhood, we do manage to keep the gardens up, and the house is always full of beautifully arranged flowers.

I am pleased that a little background history of the distaff side of the family should be included in this book, and I know that you will agree with me that Mary, the first Duchess of Beaufort must have been a truly remarkable person, and more than worthy of her place in the annals of our family.

Beaufort.

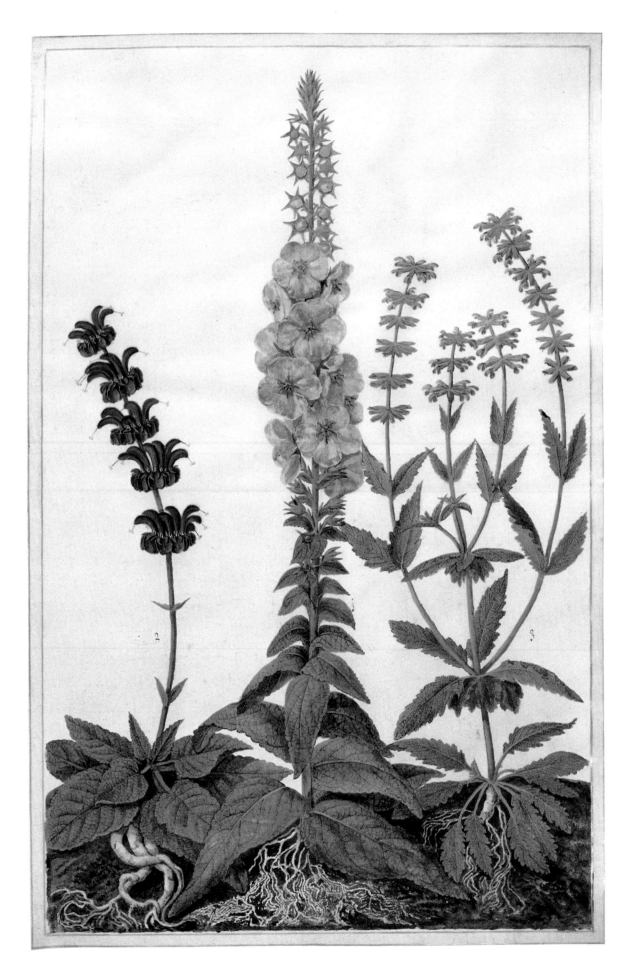

PLATE 2

INTRODUCTION

Gloria Cottesloe

Deep in the heart of Badminton House, home of the Somerset family since 1608, whose elegant north facade and great entrance hall were both designed by William Kent, there is a room that comes as something of a surprise. In what in the main is an eighteenth-century house, this room is completely out of period for, although it retains the height of the rest of the house, it is lined with black oak panelling of a far earlier date. This panelling was removed from the walls of Raglan Castle, the Welsh home of the strongly Royalist Somersets at the time of the Civil War and taken to a place of safety just in time before Cromwell's troops virtually destroyed that ancient fortress. The panelling, together with many family portraits, remained in Wales at Troy House, Monmouth, another home of the family, and was brought from there to Badminton by the present Duke of Beaufort's parents soon after he was born. Local craftsmen were employed who carefully pieced it together to fit the walls of this south-facing room that served as Queen Mary's dining-room throughout the last war, and they skilfully filled in the gaps, mounting the original panelling on deep skirting-boards to allow for the additional height of the room, while plasterers were brought in from Bristol to complete an elaborately baroque ceiling.

On a table just inside the door lie two large leather-bound books, one on top of the other, surrounded by the usual photographs and ornaments that tend to collect in a family room like this. To pick up either of these heavy tomes, to place it on a table and start turning the pages is to enter a new world of beauty, for mounted on each parchment page is a work of art - beautiful flower, butterfly and insect paintings on vellum that have retained their subtle colouring even after nearly three hundred years. The design of each picture is a masterpiece of the artist's skill - but these are not mere figments of a fertile imagination but the original and authentic paintings commissioned in 1703 by the first Duchess of Beaufort in her widowhood when she was over seventy years of age. They present an exquisite record of the flowers and plants that the Duchess grew in her own gardens, one at Badminton and the other in Chelsea where Beaufort Street runs today, her boundary running with that of Sir Hans Sloane's renowned physic garden which has been restored in recent years. Not only do these pictures show us what the flowers and their leaves were like, but the root systems and methods of propagation are also depicted in detail, together with the insects that were found on them.

Many of the plants were raised from seeds that came from places which nearly three hundred years ago must have been considered exotic - the Cape of Good Hope, the East Indies, the Caribbean and Virginia - and were carefully nurtured by the Duchess and her gardeners. The beautiful copper-plate hand-written text that accompanies each illustration reveals many fascinating truths. For example, the seeds of an Aloe from Casparo of Amsterdam that had come from the Cape of Good Hope in 1704 were kept in a stove in the Orangery - where today visitors who come to the house when it is open to the public have their tea - until eventually seven-foot-long leaves appeared. Two roots were then taken and planted under a south wall, being protected by straw and glass throughout the long winters until at last, in the summer of 1707, a flower appeared that was fifteen inches long - but, alas, this long-awaited bloom proved to have a revolting smell! The Blattaria had a yellow flower and came from Virginia 'and Buggs came out of it rather like six-legged spiders'. A rose was brought from the Caribbean that flowered as white as snow in the morning, became vividly red in the afternoon, but had finished its flowering by nightfall. A guava was raised from seed in 1692 and continued to bear fruit for the next eight years, growing to twelve feet high, 'and would have been taller had the stove been higher'.

One of these books - and perhaps it should be called the major one - was the work of a Dutch artist called Kick or Kik (Latinized in the book as 'Kychicus'), a member of a well-known family of flower painters from Amsterdam.

Brought to Badminton by the Dowager Duchess, he lived there for three years from 1703 to 1705, and while he was carrying out his specialized and intricate work it was discovered that a young Gloucestershire man, Daniel Frankcom who was employed as an under-footman in the house, also possessed a rare talent for delicate painting. The Duchess had this young man tutored by Kik, and when he had become almost as proficient as his master, she bore him off to Chelsea to work on the second of these wonderful books.

For the last two hundred years, the name Beaufort coupled with that of Badminton has served to conjure up not visions of gardens, but an immediate and vivid picture of the chase – foxhounds, huntsman and a bevy of immaculately attired and superbly mounted horsemen and women – for the Dukes of Beaufort have done more perhaps than any other family in the country to promote foxhunting at its best. Splendid horsemen all of them, several, including the present Duke, have hunted hounds themselves providing great sport and pleasure for several generations of Gloucestershire followers.

Since the last war, Badminton has also become universally famous for its Horse Trials. Held in April each year after the close of the foxhunting season, around which the farming economy of the Badminton Estate has always been run, these Trials not only attract competitors who come from all over the world with their horses, but during what has become known as 'Badminton Week' more than a quarter of a million spectators throng the Park where a course of dauntingly impressive obstacles is built each year. The course is designed with a positive aim in mind, that of terrifying the riders when they walk the course, but at the same time proving perfectly possible for horses of Olympic calibre to complete. Many members of the Royal Family, including The Queen, stay with the Duke and Duchess at Badminton House for the Trials.

Nor must we forget the well-known game that bears the name of Badminton. What is not so well known is the fact that the game was named after the house, for it was invented by the present Duke's great-aunts one wet and windy day when they were unable to go out. Taking their home-made battledores and shuttlecocks into William Kent's imposing entrance hall, lined with the huge pictures specially painted for it by John Wootton, they worked out the rules of their new game. Now, a hundred years later, the dimensions of present-day badminton courts are governed by those of that hall.

But the history of Badminton House goes back much, much further than a hundred years. It was in 1608 that the present Duke of Beaufort's ancestor, the 4th Earl of Worcester, bought the house and the land that lies around it. What was then described as a 'fayre stone howse' had belonged to a family called Boteler for more than four hundred years – so Badminton has housed only two families in nearly eight hundred years.

In 1601 Edward Somerset, 4th Earl of Worcester (1549–1627), was made Master of the Horse by Queen Elizabeth I in succession to two of her favourites, the Earls of Leicester and Essex. This appointment was a surprising one, as Lord Worcester was known to be a staunch Roman Catholic, but the Queen is supposed to have said that he reconciled what she believed to be impossible, for he was a stiff Papist while being at the same time a loyal subject. This post was no sinecure, for the Master of the Horse was responsible for all the Monarch's horses at a time when the horse was the only feasible means of transport, and he also had to maintain her studs, her racing stables and arrange her itinerant journeys around the country. On finding, therefore, that he had to spend increasingly more and more time away from his home in Wales, he started to look around for a property lying roughly half-way between Raglan and London, and so it was that eventually he found Badminton.

When his great-grandson, Henry Somerset who was ultimately to become the 1st Duke of Beaufort, inherited Badminton in 1655, it was during the time of the Commonwealth. The young man had returned from exile in the Low Countries five years earlier, leaving behind his father, the 2nd Marquess of Worcester, and on arriving in this country he was strongly advised to change his religion from Roman Catholic to Protestant if he hoped to regain any of the family's Welsh property. Being not only ambitious but also extremely shrewd, he followed this advice and appeared at the Chapel in Whitehall. By so doing he forged a degree of friendship with Cromwell that enabled him to reclaim part of the lost Welsh estates and also later on to secure his inheritance of Badminton.

He then settled down to remodel the house, and eventually changed it from the 4th Earl of Worcester's moderate-sized Tudor mansion into a far more imposing building. Not only did he rebuild the house, but he also laid out impressive gardens, and in this work he was helped by his wife. Soon after he came to Badminton he started to court a young widow, Mary Beauchamp, eldest daughter of the cavalier martyr, Arthur, Lord Capel* of Hadham in Hertfordshire.

*I have used the spelling of Capel which is the one favoured by the present Beauforts, though the Essex family name is Capell, and that was the way it was spelt in the seventeenth century.

10

Mary, first Duchess of Beaufort as she ultimately became, changed her name as many times as a modern film star for, born Capel, she married Henry Seymour, Lord Beauchamp, in 1648 when she was eighteen while her father was being besieged by Cromwell's troops at Colchester. Widowed after only six years, she married Henry Somerset, Lord Herbert, in 1657, thus becoming Mary Herbert. Ten years later he succeeded his father as Marquess of Worcester, and was eventually created 1st Duke of Beaufort. Not only did Mary Beaufort herself become a Duchess, but her son by her first marriage was created Duke of Somerset when that title was revived at the Restoration – a title that could have been disputed by her present husband as he was descended from the original fifteenth-century Duke of Somerset. Had her eldest Somerset son not been killed in a coaching accident only a year before his father's death, she would have been the mother of two dukes of different families.

Mary Beaufort's Capel blood must have enriched the already illustrious blood of the Somerset family, a family that has always prided itself on its direct Plantagenet descent from John of Gaunt by his mistress, Katherine Swynford, who later became his third wife, for Mary's father was described by Clarendon as a hero of the first water:

> . . . a Man in whom the Malice of his Enemies could discover very few Faults; nor his Friends wish better Accomplish'd: his memory all Men lov'd and reverenc'd, he had always liv'd in a State of Plenty: no Man more happy in his Domestick Affairs, and was the more so because he thought himself most Blessèd in them. And yet the King's Honour was no sooner Violated, and his just Power Invaded: then he threw all these Blessings behind him, and frankly Engag'd his Person and fortune in all Enterprizes of the greatest Hazard and Danger . . . He can never think himself under-valu'd when he shall hear that his Courage, Virtue and Fidelity is laid in the Ballance and compar'd to that of Lord Capel.

A magnificent obituary for what must have been a truly brave man – a man who perished on the scaffold only a few weeks after his beloved King, Charles I, and whose dying wish was that his heart should be cut from his body to be buried at the feet of his martyred king.

That Mary Beaufort shared her father's qualities of virtue and fidelity to the full is evidenced by the following lines in her husband's hand (given here with the original spelling) that are framed at Badminton together with their certificate of marriage:

M – ost men, more Loves than one enjoy
A – nd never find, to them a Woman Coy
R – emember that I have but one, who is
Y – oung and constant, I'l have none but this:

B – eauty she has, and yet, to me is true,
E – ver yeilding what to me is due,
A – m not I above all others blest?
U – nder such charming Looks to rest,
F – ree from all frowns, or Jarrs,
O – f wenches, whose smiles are Scarrs.
R – ead this, and you will find,
T – o Love, but one woman is my mind.

The correspondence between husband and wife that rests in the Muniment Room at Badminton, the sand used to dry the ink is still visible three hundred years later, is a testament to the continued love and devotion that existed between them. Tragically, although she bore him five sons and four daughters, only five children grew up, and most of these, and her two Seymour children, predeceased her.

Sorrow she had in plenty, but she must have inherited more than her fair share of her father's courage, for she ran the Badminton estates on her own through all sorts of vicissitudes, including a two-month sojourn by her husband in the Tower of London following an abortive attempt at a Restoration in the summer of 1659, just a year before King Charles II did return to mount the throne. Mary Beaufort had every reason to dread the very name of the Tower of London, as her first husband, Lord Beauchamp, was imprisoned there soon after they were married, and he contracted the malady there that was finally to kill him in the prime of his youth. Her father, too, was sent to the Tower and, although he escaped, he was betrayed by a waterman who received £20 for the deed, and sent back to await execution.

During her husband's frequent absences when he had to attend Parliament and to give the King his support at Court, Mary Beaufort kept her finger firmly on the pulse of the great house. A kinsman, Lord Keeper Guilford, who once spent a week there, threw light on her thoroughness and the shrewdness of her character when he wrote:

> . . . every day of her life in the morning she took her tour and visited every office in the house, and so was her own superintendent – observed anything amiss or suspicious, as a servant riding out or the like. Nothing was said to that servant, but his immediate superior or one of a higher order was sent for, who was to inquire and answer

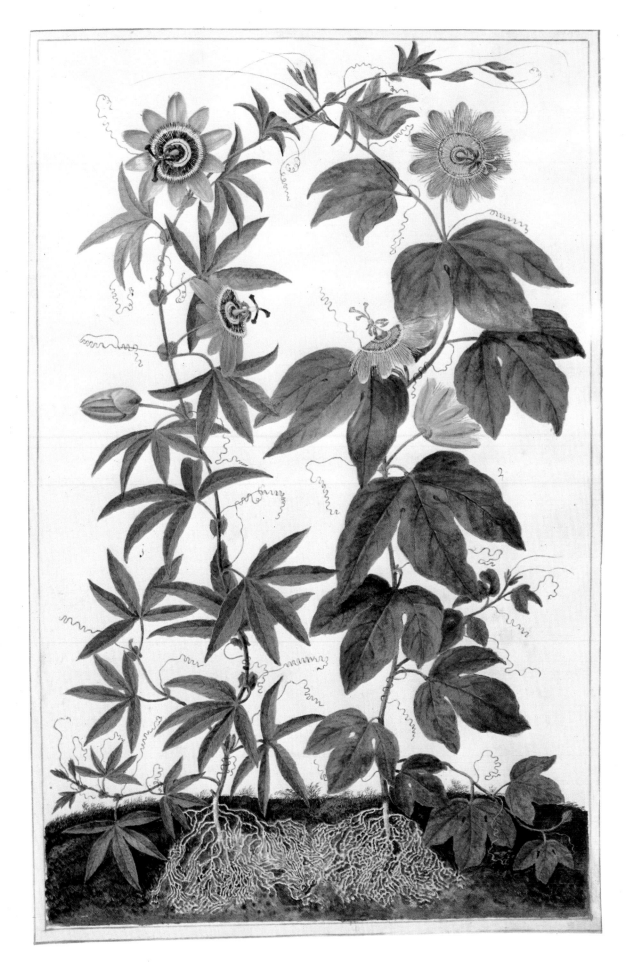

PLATE 5

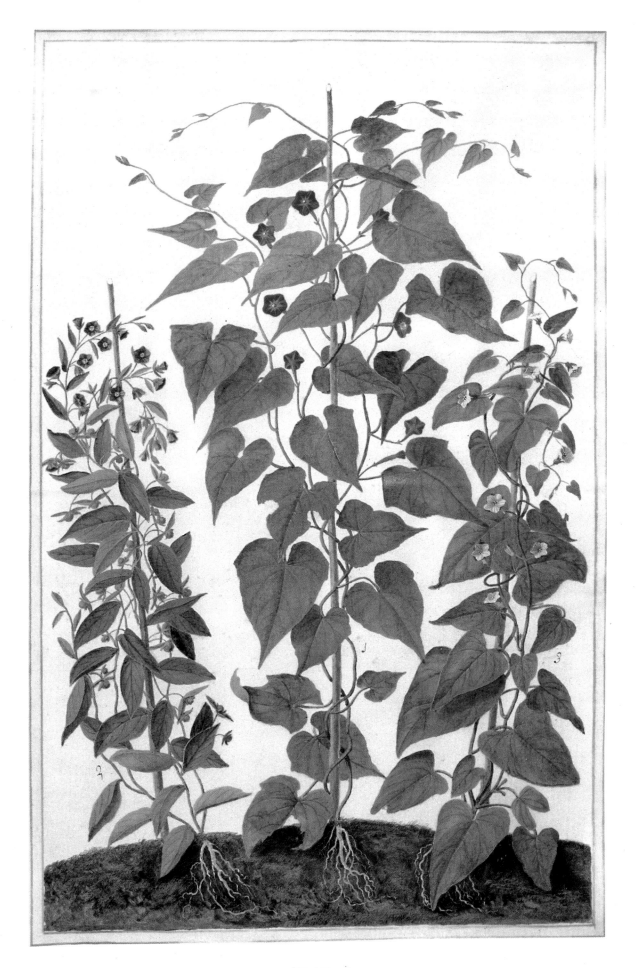

PLATE 6

if leave had been given or not. If not, such servant was passed by, for it may be concluded that there are enough of these that pass undiscovered.

Gardens played an important part in the lives of all the Capels, and Mary Beaufort's eldest brother, Arthur, who was given the Restoration title of Earl of Essex to honour his father's memory for the courageous part he had played in the King's cause, was a notable horticulturist. He employed Moses Cook to lay out wonderful landscape gardens at Cassiobury, the estate he inherited through his mother, daughter of Sir Charles Morrison, himself a distinguished gardener. John Evelyn, the diarist, whose favourite pursuits were horticulture and planting, paid a visit to Cassiobury in 1680 and wrote, 'No man was more industrious than the earl in planting.' He went on to say that even though the estate was on 'stoney, churlish and uneven' soil, it was richly adorned with walks, ponds and other rural elegances, including a pretty oval at the end of a fair walk, set about with treble rows of Spanish chestnut trees. The land about was 'singularly addicted' to woods, though, owing to its 'coldness', not all kinds of trees would grow well. What caused Evelyn most amazement were great avenues of wild black cherry trees, some of which grew up to eighty feet in height.

This Earl of Essex, like his more famous namesake, Queen Elizabeth's favourite, fell a victim to politics, even though he had held high offices, for he was Viceroy of Ireland for five years and then first Lord Commissioner of the Treasury. Together with other well-known aristocrats, he was not in sympathy with the dissolute way of life adopted by Charles II, and they shared a common loathing of James, Duke of York, later James II, and so Essex became mixed up in an ill-fated conspiracy, known as the Rye House Plot, in 1683 – just a year after his brother-in-law had been created Duke of Beaufort.

The royal brothers would almost certainly have lost their lives had it not been for a fire in Newmarket which caused them to travel to London a week earlier than expected. Informers, always conspicuous when plots are being hatched, warned the authorities that an attempt was going to be made to depose both Charles and his brother, after which a republic was planned – though contemporary opinion inclines to the view that regicide was never intended. The outcome was that a number of arrests were made, including that of the Earl of Essex who was found walking innocently in his garden. Three men were hanged forthwith but four others, deemed more important, Lord William Russell, Algernon Sidney, John Hampden and the Earl of Essex, together with the Duke of Monmouth and Lord Howard, were charged with forming a council of six for the purpose of organizing an insurrection. Russell and Sidney were summarily beheaded, Hampden heavily fined and Essex thrown into the Tower. However, he did not wait for the course of justice, but took matters into his own hand by cutting his throat with a razor.

Evelyn, who had described Essex as sober, wise, judicious and a pondering person, had grave doubts as to whether this was in fact a case of suicide:

. . . for the wound was so deepe and wide, that being cut thro' the gullet, wind-pipe, and both the jugulars, it reached to the very vertebrae of the neck, so that the head held to it by a very little skin as it were; . . . an executioner could hardly have done more with an axe.

Evelyn added, 'There were odd reflections upon it' and by the strangest coincidence, the King himself, accompanied by his brother, the much-detested Duke of York, happened to visit the Tower at the very moment of Essex's death. On hearing the news, instead of condemning the Earl for his disloyalty, Charles magnanimously said: 'My Lord of Essex need not have despaired of mercy, for I owed him a life.' He was referring, of course, to Essex's father, the martyred Lord Capel.

Mary Beaufort's other brother, Henry, who became Lord Lieutenant of Ireland and was later created Lord Capel of Tewkesbury, married Dorothy Bennett, heir to Kew House, and there he created a wonderful garden on ground considered too sour for anything ever to grow and flourish. Henry Capel's great speciality was fruit, and he built two huge glasshouses for oranges and 'myrtiles', novel in that they could be reached from the house, precursors of the conservatories that later became a feature of most large houses. His other speciality was 'greens' or, as we know them, evergreens, and he had yew hedges that were grown in a new fashion, for at regular intervals along these hedges, some plants were permitted to grow tall and then were 'kept in pretty shape with tonsure', these being among the earliest examples of topiary. After the death of his widow, Kew House and its garden passed to his great-niece, Lady Elizabeth Molyneux whose husband was secretary to George II when he was Prince of Wales. Later still, in 1730, Frederick, Prince of Wales, obtained a long lease on Kew House and planned a fresh pleasure ground, employing William Kent to lay out additional plantations, thus providing the foundations of the Kew Gardens we know today, home of the Royal Botanic Gardens.

Meanwhile, Henry Beaufort spent the last ten years of his life at Badminton, for he never took the oaths to William III, preferring to retire from public life. He died

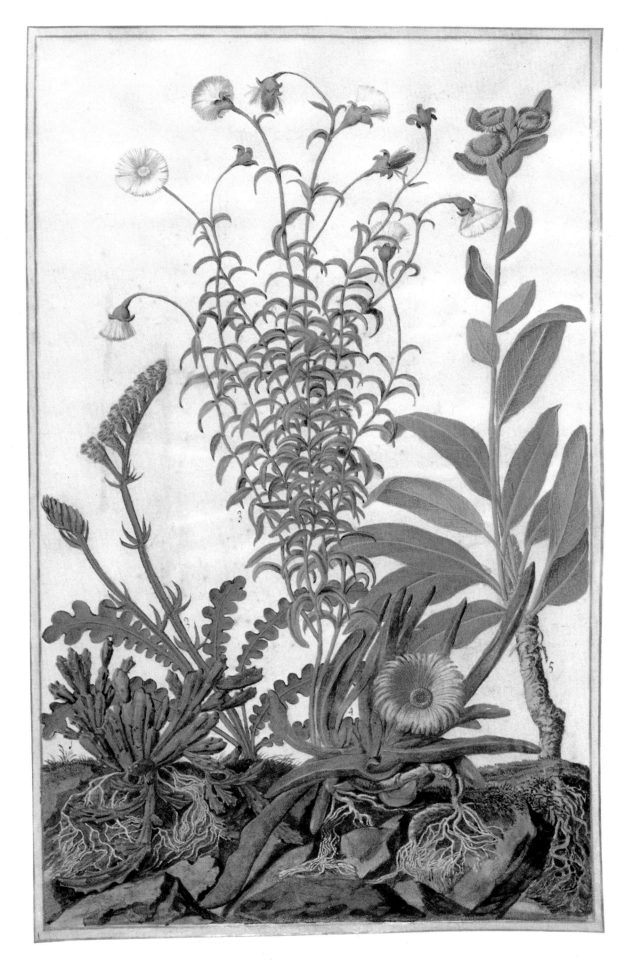

PLATE 7

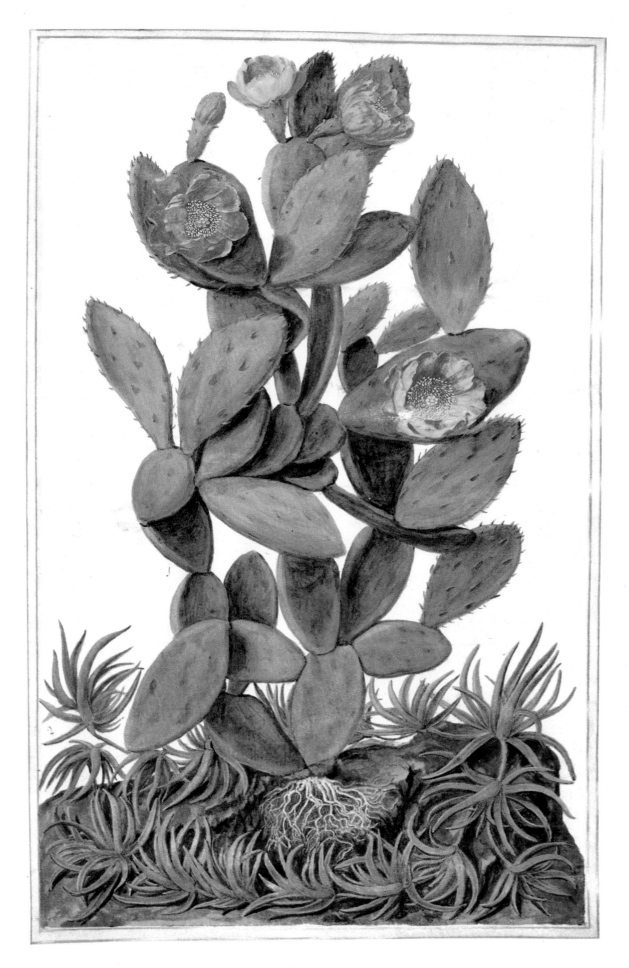

PLATE 8

in 1699 and was survived by Mary, who lived on for sixteen years. During that time she continued her interest in gardens and rare plants 'tending her collections of thousands of exotics, drawn from all over the world, which she kept in a wonderful deal of Health, Order and Decency'. She was praised by her friend and neighbour in Chelsea, Sir Hans Sloane, for her skill with tender plants which she nurtured in what she called her 'infirmary' and he commented that she brought them to greater perfection than those at Hampton Court 'or anywhere else'.

The selection of pictures in this book, with their wealth of detail, their delicacy, amazingly subtle colours and the superb designs of their portrayal, form a most appropriate memorial to a truly remarkable lady, Mary, first Duchess of Beaufort.

Notes on the paintings

Many of the plants so beautifully painted for these manuscripts look familiar because they are still grown in our gardens today, but others have been difficult to identify due to changes over the years while the plant has been in cultivation and because a type may have disappeared and when this happens, sadly it is lost for ever. Fortunately many descriptions in the index are of the longer form which was used before Linnaeus introduced his two-word nomenclature, so we find a Latinized sentence showing a name given to the plant at that date, details of its form and sometimes a place of origin. For the paintings reproduced here the modern name has been found as far as this is possible – the family, the genus and species – and a note has been made of their correspondence or difference from the originals.

The Swede Carl Linnaeus produced his *Species Plantarum* about fifty years after the death of the 1st Duchess of Beaufort, but she obviously had access to many catalogues and lists for reference, and these are recorded in the index of the manuscripts. Both Pliny, the Greek philosopher, and Dioscorides, the physician and herbalist of the first century, are mentioned. The latter produced one of the first lists of herbs in his *De Materia Medica* from which later botanists often quoted. Centuries afterwards John Gerard, an apothecary of London, printed his *Herball* in 1597, in which comments on the plants' usage and 'vertues' are apt and sometimes amusing. So many plants had the date 1596 for their introduction to Britain that it has been suggested that, when in doubt, later writers may have attributed a plant to this date, a year before the publication of the *Herball*. John Parkinson of Ludgate Hill, like Gerard a London apothecary, published a valuable book in 1629, the first gardening dictionary called *Paradisi in Sole Paradisus*

Terrestris which is a pun on his name and can be translated as 'Parkin-sun's earthly paradise'. The Duchess who obviously used these lists also had wider contacts. The index mentions J.P. Tournefort, head of a French school of botany, who first defined 'genera', John and Caspar Bauhin, Swiss brothers, also Mathias de l'Obel and C. de l'Ecluse of the Flemish School of botany and later the school at Montpellier, France.

The Renaissance was a great period for the development of horticulture for so many unusual plants and new seeds were brought to Europe from far countries. They were welcomed with enthusiasm and grown with much care by gardeners who often competed for the finest plants of greatest interest. Plant collectors such as the John Tradescants, father and son, brought specimens from North America, southern France and even Russia while Jacob Breyn of Danzig was one of the enterprising traders who returned from the East and West Indies with new plants. Seventeenth-century explorers penetrated further into the tropical countries finding new plants to be named by the botanists at home, such as John Ray at Cambridge, Robert Morison at Oxford and Leonard Plukenet, all contemporaries of the Duchess and mentioned in the notes that accompany the paintings. So many plants were recorded in the index as coming from the Cape of Good Hope that one could assume that the Duchess had a special contact there.

It is noticeable that the paintings are of special plants; there are no roses, pinks, gilliflowers, pansies or violets and the bulbs are only included if of some unusual type; the Duchess was certainly a connoisseur of plants and their growth.

As might be expected her garden was extensive. Near the house were knot gardens of geometrical design filled

with flowers of one colour, bordered with clipped box or herbs and using also coloured gravels. Beyond that were parterres, evidence of the French influence which came in after the Restoration, larger scale designs with higher clipped hedges and topiary work. There were many orchards with pleasant arcades and sheltered bowers. The Duchess might have been advised by William Kent (1684–1748) who was employed by the 3rd Duke in connection with alterations to the house, for Kent was also an expert garden designer. There was a movement at the time for the impressive use of trees, after the publication of John Evelyn's *Sylva*. Avenues of trees were planted leading out from the house and gardens in the form of a great star. Some of these avenues, restored by the present Duke, can be seen to this day despite the loss of the elms as a result of Dutch Elm Disease. The tender evergreens or 'greens' as they were called were housed in a greenhouse, hence its name, but it would probably have had a solid roof and a stove for heating. The Duchess also had an 'orangery' similar to one her brother was building at Kew. This great interest, vast knowledge and practical ability was recognized at a later date when a plant was named after her, the *Beaufortia*. It was an elegant free-flowering myrtle from Australia, a tender evergreen shrub with purple or red flowers. In 1787, not long after Captain Cook brought back plants from Botany Bay, the *Botanical Magazine*, in its first year of publication, stated: '*Beaufortia*, in commemoration of Mary Somerset, Duchess of Beaufort, a patroness of Botany.'

Doris Hunt

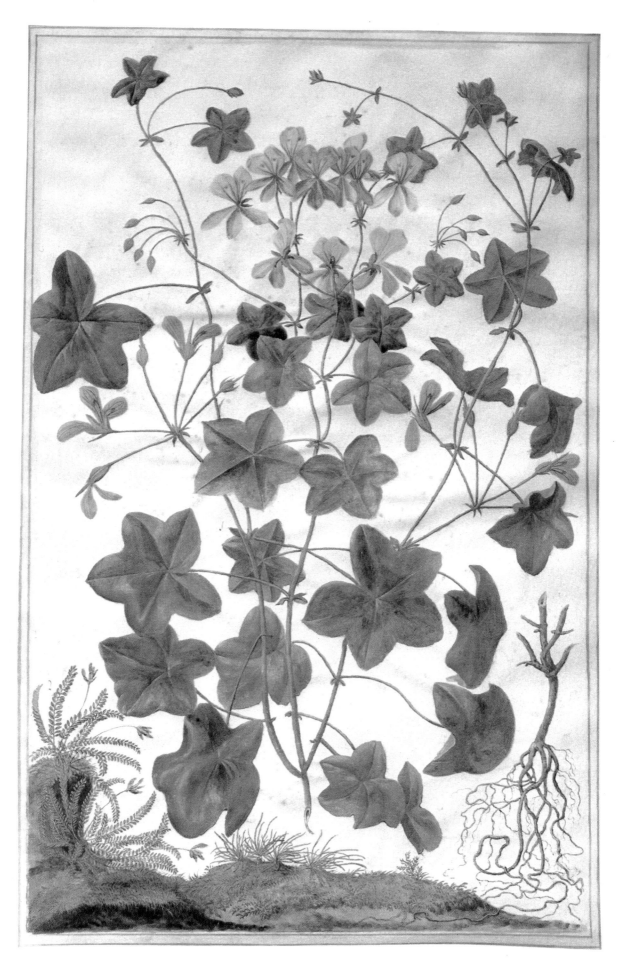

PLATE 9

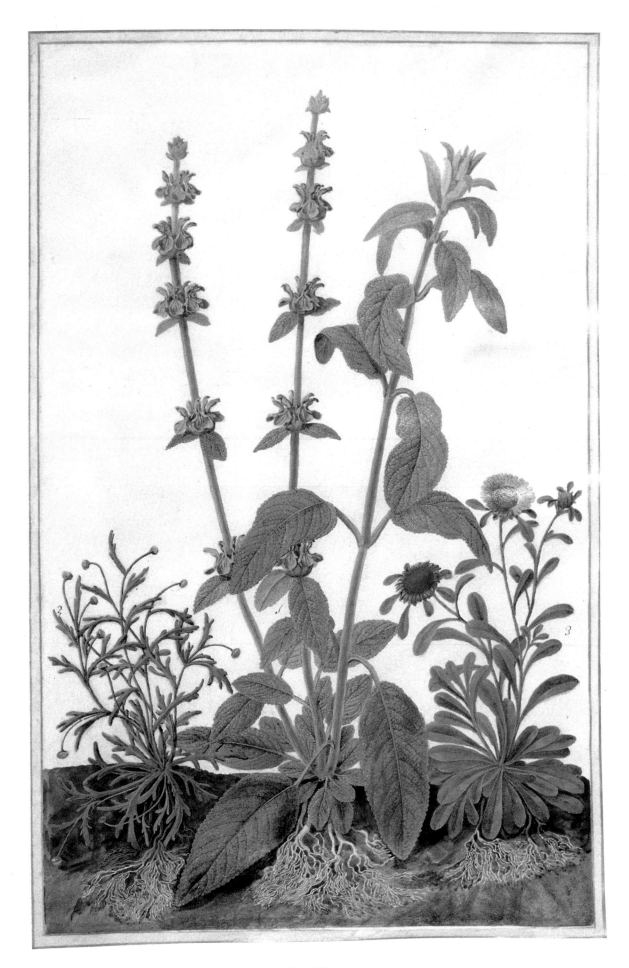

PLATE 10

DESCRIPTIONS OF THE PLATES

Doris Hunt

Plate 1

Asparagus, Butcher's Broom and Fern

Here is an interesting group in which Kychicus has illustrated three very different plants which have in common an unusual leaf formation.

The centre one is *Asparagus acutifolius* which he says in the index was obtained from the Straits of Magellane, Zeylanica (Ceylon). This species is recorded as having come from Spain in 1640 so perhaps it might be assumed that the Duchess obtained these seeds or rhizomes direct from the navigators. There was quite a competition amongst horticulturists of that time to procure the newest plants. This is a half-hardy shrub bearing tufts of green bristle-like branches in the axil of minute leaves; in other words the apparent triple leaves are really branches.

Of course the plant is related to *Asparagus officinalis* whose young shoots we eat, which was called 'spherage' by Gerard and nowadays is sometimes called sparrow grass or sprue when small. Asparagus belongs perhaps surprisingly to the lily family, hence the bulbs or tubers in the picture, but *A. officinalis* usually has rhizomes.

Hippoglossum is the name given by Kychicus to the plant on the left which has red berries that appear to come from the middle of the leaves. It is known as butcher's broom or box holly, *Ruscus hypoglossum* and is also a member of the lily family although it looks so different from the asparagus. Here the apparent leaf is really a flattened stem or branch called a cladode or phylloclade. It functions as an evergreen leaf for again the real leaves, which are deciduous, are very small and grow at the base of the cladode. The flower grows from this flattened stem, hence the position of the berry. The hypoglossum species – the name means tongue-under-tongue – came to Britain in 1596 and as butcher's broom can be found wild in the woods of the south, where it is perhaps a garden escape.

Phylites is the name given in the index to the plant on the right, another plant with a strange leaf form. The end of the leaf fans out into finely waved, closely curled terminals, described as *crispa folio*. It is a form of hart's-tongue fern, *Scolopendrium phyllitis*, chosen perhaps deliberately for the use of the word 'tongue' again.

Plate 2

Verbascum and Salvia

Blattaria is the name given to the yellow spike in the centre with the suggestion that it may be a verbascum (*sive verbascum*) introduced from *lusitaniam* (Portugal). A name used now is mullein or moth mullein which appears to be of a later date and to be related to plants or seeds which came from Muli, a region of south-west China.

This plant is a little different from the quite common stately, grey-leaved, biennial spike, often growing to five or six feet in waste places or as a surprise visitor to the garden, when a seed dropped by a bird has germinated and not been weeded out in its first year. The blattaria depicted in this plate is not so large and not nearly so downy, the yellow flowers are larger *lutea ample* with purple instead of white filaments to the anthers. In mediaeval times it was a symbol of love.

The number of names given to verbascum through the years indicate its varied usefulness to man. The Romans dipped the dried spikes into tallow and used them as processional torches, hence *candela regis* and *candalaria*. There are names with biblical origins such as Aaron's rod, Jacob's staff and Adam's flannel. Haresbeard refers to the downy hairs, called hag or higpipes, which were used for the centre of a wax nightlight. An infusion of the leaves was supposed to cure a cough in cattle, hence cow or bullock's lungwort, but for humans it was reputed to relieve diarrhoea. Pliny is said to have recommended the use of the leaves to wrap round figs, for by this means they ripened without putrefaction.

The plants on the right and left have flowers in whorls

suggesting that they belong to a common family. They are indexed as horminum which is a species of salvia belonging to the genus Labiatae, a family which contains many aromatic plants including sage, mint, thyme, lavender, bergamot and marjoram. There is a characteristic two-lipped shape to the flowers which is an aid to fertilization, for the insect alighting on the lower lip brushes against the stamens and styles held in the concave curve of the upper one. A number of this family have the unusual feature of bright-coloured sepals instead of the usual green, which make them appear to be petals – in particular *Salvia splendens*, a rich red raceme used often as a bedding plant in modern gardens and clary, *S. sclarea*, with pink and white bracts, a plant used in the manufacture of perfumes and wine. Clary was also used in the past as a salve for eyes, *sclarea* means clear eyes. In fact, the name salvia comes from the Latin *salvus* meaning safe well or save all, and the flower symbolizes 'health and longevity'.

Horminum came to this country in 1696, as an annual from southern Europe. The one on the left has blue-purple flowers and sepals in close whorls with ovate and crenated leaves. The one on the right with the branched form and pinkish flowers, named *sylvestre* meaning 'from the woods', is not unlike the wild wood woundwort, *Stachys sylvatica*, a member of the same family, which is also reputed to heal wounds. In fact Gerard became enthusiastic over its power to heal open wounds quoting cases of its use in the field where it was picked fresh to staunch bleeding and also mixed with hog's grease for use as a poultice.

Plate 3

Thistle, Hyacinth and Asphodel

This golden thistle is the Spanish oyster, *Scolymus hispanicus*, which grew in many places in southern Europe in addition to Spain and Portugal. The yellow compositae blooms appear to be supported by a surround of prickly leaves which merge into the equally spiny stem. This is an easily grown biennial or perennial whose stems and roots are edible rather like salsify. Gerard knew it and quotes Pliny as commending it as a poor man's supper.

The beautiful white blooms on the right are from the asphodel which also came from southern Europe. The

name asphodel is derived from *a* meaning 'not' and *sphallo* meaning 'to surplant', an allusion to the unsurpassable beauty of the flowers. The delicate painting of the white turned-back petals and the long stamens is another delightful example of the work of Kychicus.

The hyacinth on the left is easily recognized but others painted by Frankcom are not so familiar. In particular there is one that he calls a 'blew tuberose' possibly *Polianthes tuberose*, which is depicted with a tight raceme of double flowers and, according to the index, came from Mexico in 1629.

All the hyacinths we grow now in pots or the garden are derived from the *Hyacinthus orientalis* bulbs which came with others into England during the reign of Elizabeth I. They possibly came from the Levant as a result of the encouragement the Queen gave to traders who visited Persia for raw silk, carpets and other commodities. Although the bulbs may have been brought to England it was the Dutch in the neighbourhood of Haarlem who hybridized them to produce the different colours and develop the marketing industry. Peter Voerhelm was one of the early cultivators of the double hyacinth depicted here but sadly we seem to have lost it through the years.

Mythologists tell us that the flowers sprang from the blood of Hyacinthus, who was greatly beloved by both Apollo, the sun god, and Zephyr, the west wind. Hyacinthus preferred the sun to the wind and caused so much jealousy in the latter god that Zephyr caused his destruction. One day Apollo and Hyacinthus were playing quoits, a game in which flat metal rings are thrown over a post; when Apollo's quoit was in the air Zephyr blew it towards Hyacinthus's head, fatally injuring him. Apollo was so grieved that he changed the drops of blood from Hyacinthus's head into the flowers we call hyacinths.

The legend was commemorated in ancient Greece by the yearly feast of Hyacinthia, and crowns of the blooms were worn by Greek virgins when they assisted at the wedding of a friend.

Plate 4

Thistle

The description given in the manuscript of this particular thistle is *Carduus tormentosa Acanthium dictus Arabicus*

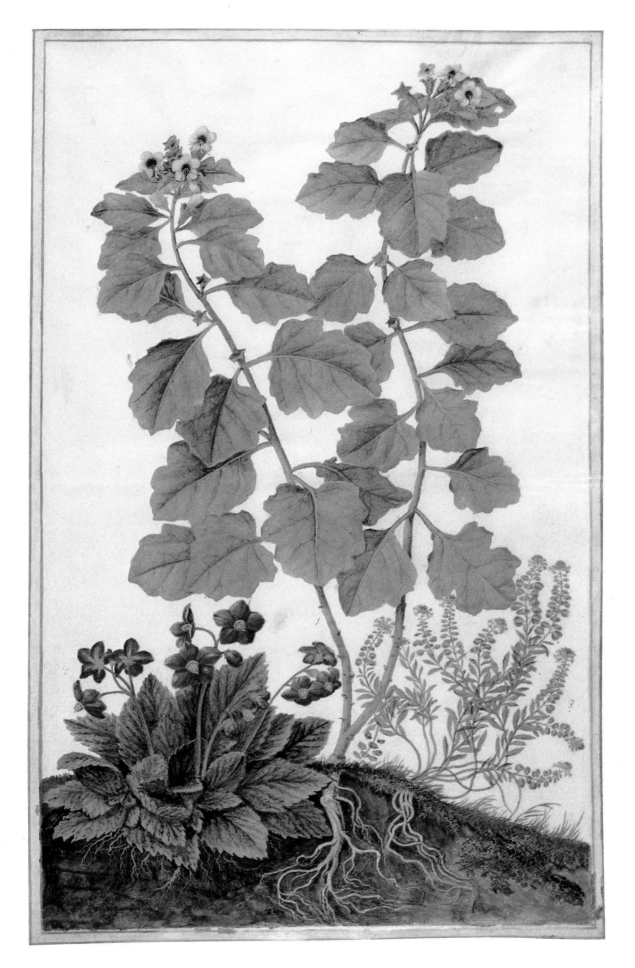

PLATE 11

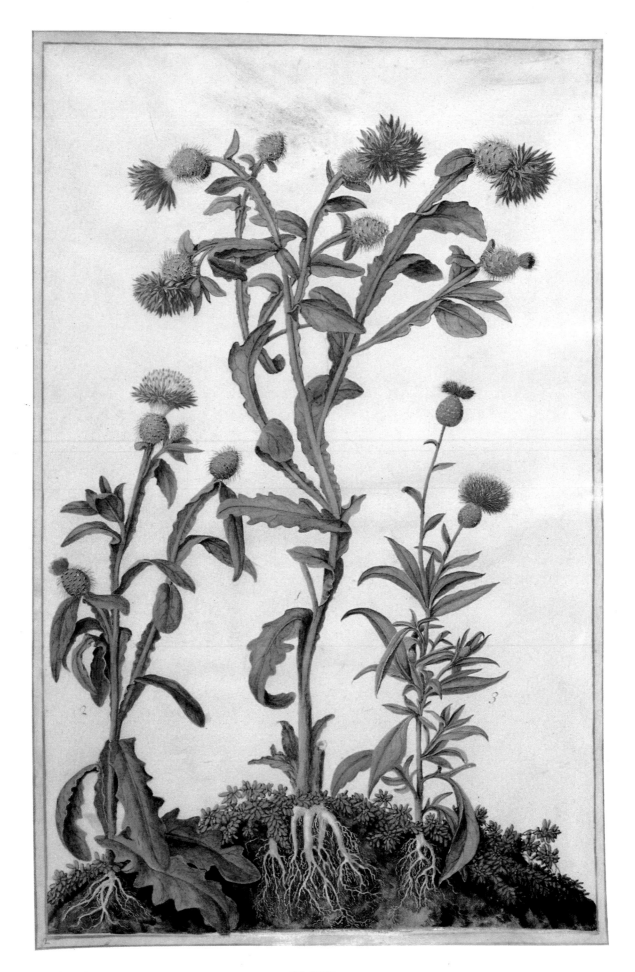

PLATE 12

which clearly refers to the Scottish thistle, the large ornamental kind which is a garden biennial growing to a height of five feet. *Acanthus* describes the thorny, spiky nature of both stem and leaves which is so in contrast with the soft delicate thistledown; *tormentosa* means downy and *Arabicus* indicates its place of origin.

Kychicus also painted other thistles including the *Silybum marianum*, called the Blessed Mary Thistle by early botanists to preserve the legend that the white spots on the leaves were caused by falling drops of the Virgin Mary's milk. The stems of these are edible but surely they are more to the taste of donkeys as suggested by the modern name, *Onopordum acanthium*, which comes from the Greek word *onos*, an ass.

Thistles are said to grow well on good ground and there is a story of a blind man about to buy a piece of land, who bent down and felt thistles growing and so knew it was worth buying.

The thistle is the floral emblem of Scotland and the Order of the Thistle has a golden collar of St Andrew's crosses interlaced with thistle flowerheads. There are many versions of the story of the adoption of this emblem but perhaps the one that is most commonly accepted is that dating from the time of Malcolm I, in the tenth century. It is said that Norsemen were attacking a beleaguered castle and one night they took off their footgear in order to wade the moat only to find it dry and full of cotton thistles. Their yells of pain and presumably the swear words of the day roused the garrison and they were soundly defeated. The people of Scotland were so grateful for their deliverance from the enemy that later in memory of this victory, they chose the thistle as the floral emblem of their country.

'The thistle shall bloom in the land of the brave' (anon).

Plate 5

Two Passion Flowers

Here we have two passion flowers. *Passiflora caerulea* is the one on the left, white with the rings of purplish blue, denoted also by Kychicus as *caerulea* and *pentafilia* for the five-lobed leaves. This is fairly hardy and can be grown outside in southern parts of Britain. The plant depicted on the right has a pinkish bloom with a darker centre and

is a different species with *trifolia* or three-lobed leaves, probably related to the *radianna*. Both species were introduced early in the century when the Duchess was collecting her plants but in the index they are classed as a species of clematis, *Clematis passiflora*. These plants were painted with even more care and exceptional observation, for the flowers last but one day and are of a somewhat complicated formation. There is an outer ring of petals and then a further colour-shaded crown, while the stigma and stamens are of an unusual shape, standing well out from the corona and difficult to paint without three dimensions.

The story is told that missionaries visiting Mexico saw to their astonishment a sort of vine growing with a flower resembling the one which, according to Christian legend, St Francis of Assisi saw on the Cross in a vision. It was said to represent the various symbols of the Crucifixion: the ten petals symbolize the ten faithful apostles, the two missing being Judas who betrayed his Lord and Peter who denied Him; the outer corona symbolizes the many disciples and the inner one the crown of thorns; the five stamens represent the five wounds, the three styles with rounded heads, the nails and the ovary the hammer. Hence the flower was named by the Jesuits *Flos Passionis*, passion flower or the Flower of the Five Wounds. The natives were found to enjoy eating the fruits so it was assumed that they were thirsting for Christianity and it was reported that in a surprisingly short time a number were converted.

Plate 6

Three Convolvulus Plants

These three convolvulus plants are described by Kychicus as *C. caeruleo minimo* or small blue, *C. coccineus*, scarlet and *C. albo minimo*, small white. The blue flower on the left has a white and dark centre and may be *C. tricolor* which came from Sicily, Spain and Portugal about 1629, and is very like the cultivar we now call 'Blue Ensign'. The others have the typical heart-shaped leaves of the ipomoeas which were grown in the Duchess's time, the popular blue one is known now as 'Heavenly Blue'. The artist has, as usual, carefully recorded the roots but surprisingly they are smaller than one would have expected, for the roots of the bindweed, *Convolvulus*

arvensis, go down for so many feet in our gardens that it is looked upon as a troublesome weed.

The climbers appear to twine round their supporting sticks in a clockwise direction. There has been much discussion about whether plants prefer to bind round clockwise or anti-clockwise and when studied it was found that plants of the same kind are not entirely consistent. It is suggested that the decision is taken when the first small stem reaches its first support and there is a tendency for the sun to have warmed one side of the stem which then grows at a greater rate and so bends round in one direction.

There is a species of ipomoea from Mexico, *Ipomoea purga*, which as its name suggests provides a purgative (from its tuberous roots) called Jalap. From the Mediterranean regions comes a vine-like plant, *Convolvulus scammonia*, the roots of which also have purgative properties – the drug made from them is called Scammony. Gerard knew a bindweed called 'Scammonie' with a white flower, but he says that when he went to 'Bristowe Faire', an ignorant weeder of his London garden plucked it up and cast it away. He was very cautious of its medicinal properties and commends its use only to the learned and not to '. . . runnagat physick-mongers, quack salvers, old women-leaches and such like other abusers of physick and deceivers of the people'.

Plate 7

Ficoides and Statice

Ficoides is the name given in the index to no fewer than seventeen plants painted by Kychicus, mostly small daisy-like flowers with succulent leaves shown at the base of a group. The word 'ficoides' means literally 'like a fig' but there is no resemblance to the fig leaf or family in the plants painted nor is there a plant called by that name in horticulture now. Kychicus, however, also records that they were from South Africa. Now there is in that country a plant called *vygie* in Afrikaans which means 'little fig' and refers to the edible fruits of the mesembryanthemum which is also called Hottentot fig and fig marigold. Both the fruits and the leaves of this plant have a slight narcotic content and act as a stimulant. In East Africa the crushed fruit is used in the making of bread and the ash as a source of washing powder.

It is indeed a very large family of curious plants both recumbent and tall but each having that daisy-like flower and yet not of the daisy or Compositae family. The family Aizoaceae is called after the iceplant whose fleshy leaves have innumerable translucent dots which shine like dew drops in the shade but in the sun appear as brilliant crystals, and whose leaves seem always cold to the touch. *Mesembria* means 'midday' and *anthemon* is a flower, thus the name describes the flower's habit of only opening in full sun. Dorotheanthus and Livingstone daisy are other modern names for the plants painted by Kychicus. They grow in this country from seeds or cuttings taken from the thick leaf and if placed in a sunny position provide flowers useful for bedding designs in vivid colours including crimson, purple, orange, blue and yellow. The illustration shows their versatility. The centre plant is a tall white mesembryanthemum with slim yet succulent leaves; on the right are two with yellow flowers, one a tall plant with a rough stem almost like the trunk of a tree and the other a recumbent variety with a larger flower. On the left are two not in flower but with interesting and different leaves.

Tucked in at the back is another plant, with quite a dissimilar habit. This mauve flower is statice, *Limonium sinuatum*, which grows well on sea shores, in particular those of the Mediterranean from whence it originally came. It is a plant which is valued for its property of keeping its colour when dried and is grown as an everlasting flower to this day, for use in winter flower decorations.

Plate 8

Opuntia

Here is another plant with a fig connotation but with quite a different form. Opuntia is the Greek name given to the prickly pear or Indian fig, the word supposedly coming from the ancient town of Opus in Greece, known as the town of figs. This fig should not be confused with the fruit of the broadleaved tree *Ficus* to which it has a likeness in the shape of the fruit only. Opuntias grow freely and often to a large size in Mediterranean countries but they came originally from the hot countries of the New World including Mexico and Brazil. Before the arrival of the Spaniards, the Aztecs were producing a gum called nopal

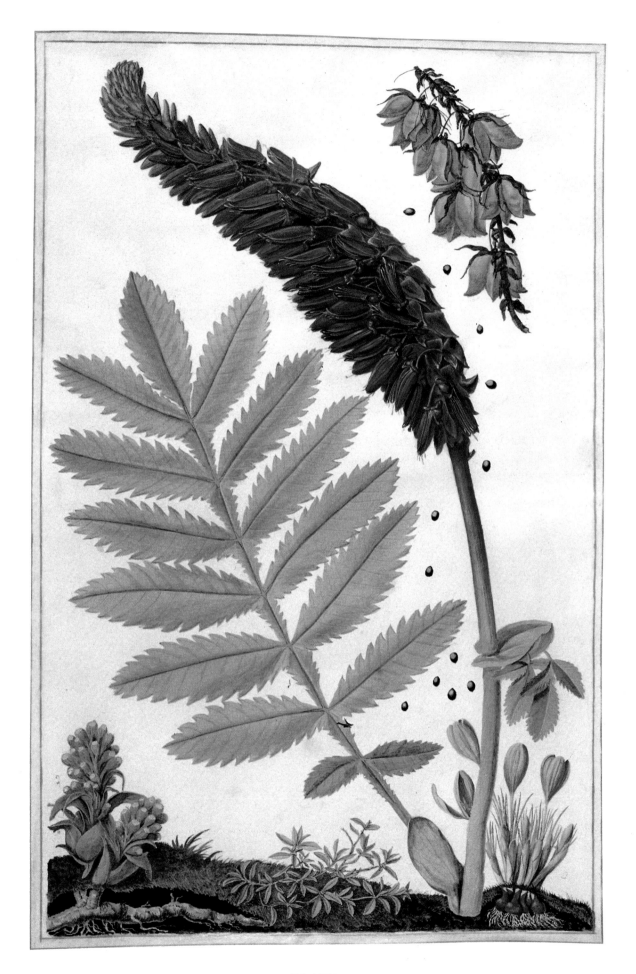

PLATE 13

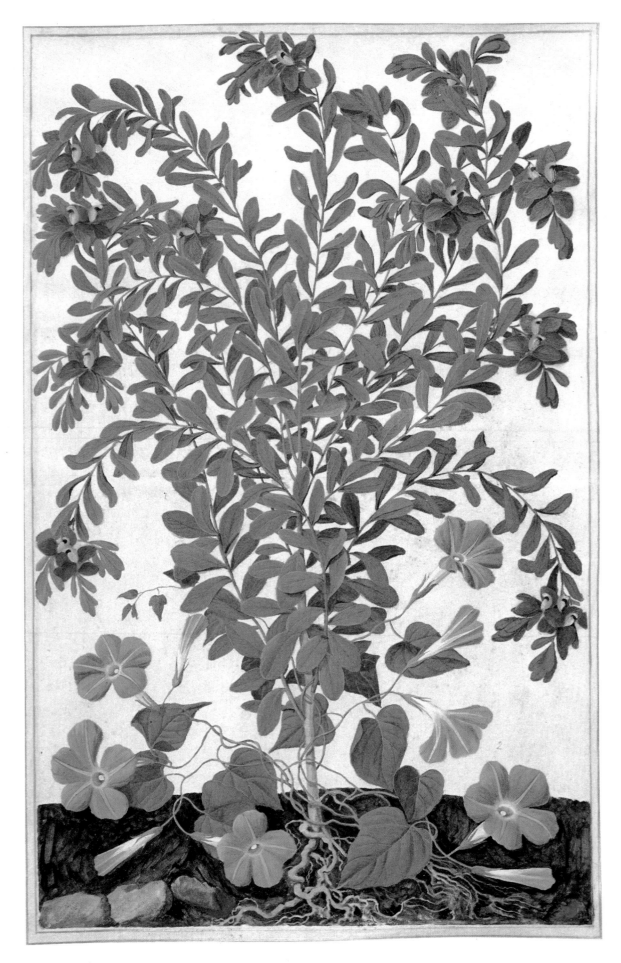

PLATE 14

from the plants from which they made various remedies including one for burns in which nopal was mixed with honey, eggs and herbs.

The prickly pieces are easily broken off to make new plants, hence it is a familiar house plant, which with care can be brought into bloom in spring; the flowers may be yellow, orange, red or purple. It is important that they should not be overwatered and one recommendation is that they should only be given water when the weather report for Mexico says rain. The flattened ovoids are really enlarged stems in which water is stored and the stomata from which the prickles emerge are vestigial leaves which may be raised areoles, barbed bristles or white spines. These have the power of hindering transpiration or holding dew, and are arranged in a geometrical spiral, one of nature's favourite structures.

The fruits of many opuntias are edible and are supposed to be nutritious. They are eaten raw or cooked as a vegetable and can be made into a fermented drink, while the plants with the spines burnt off are sometimes fed to cattle. There is one species, *Opuntia cochenillifera*, which was cultivated in tropical America to provide food for the insects that were used to make cochineal, before synthetic food dyes were manufactured.

Plate 9

Geranium

This beautiful picture of a trailing geranium is very like the modern pelargonium which is so useful for hanging baskets and window boxes. It came from the Cape about the time of the Duchess's great interest in horticulture and the root is especially painted because about that time some tuberous-rooted geraniums were imported from Italy.

The modern name is *Pelargonium peltatum*. *Pelargos* is Greek for a stork and refers to the beaklike formation of the ripe seedhead. *Peltatum* means 'shaped like a shield' and describes the way the leaf is supported by the stem, which is attached to the back surface of the leaf, away from, and not at, the margin. This is clearly seen in the painting for the veins meet at a point which is inside the leaf and the stem must grow underneath from that point. Ivy-leaved geraniums have this shield formation which is noticeably different from that of the zonal and other species where the leaf veins lead from the stem with the usual spread at the start of the leaf.

Since its introduction, this plant has given rise to cultivars many of which have been lost and new ones produced. A scented leaved species also came in with the early navigators from the Cape in the seventeenth century. When bruised the leaves of this species give off a number of varied perfumes, which are sometimes used for flavouring cakes or puddings. If a leaf is placed under the paper lining in the bottom of a cake tin, the scent will give the baked cake an unusual and pleasant taste.

The small plant on the left with the very pinnate leaves was called *Ornithipodium majus* by Kychicus and it is obviously what we call 'bird's foot', from *ornis* a bird and *podus* a foot. It belongs to the pea family but the flowers are small which makes the seed shaped like a bird's foot more striking. Because of the pinnate or fern-like leaves it is not the wild bird's foot trefoil but a less-common bird's foot called *Ornithus perpusillus*, which has very small white flowers.

Plate 10

Salvia, Chysanthemum and Aster

Kychicus's index entry refers to the centre plant as *Horminum Sylvestre Italicum* which suggests that it is a salvia or sage growing in the shelter of trees and that it came from Italy, but it has a smooth ovate leaf resembling that of wood calamint or savory, another herb that grows in the south of England but which prefers chalk. These herbs, and some shrubs, were the only autumn blossoms available in Shakespeare's time. However, by the time the Duchess had her gardens at Badminton and Chelsea in the seventeenth century, so many plants had been introduced from the New World and the Far East that the gardens must have looked much brighter in the fall of the year.

An example would be the aster and chrysanthemum also illustrated here although it is quite obvious that they are very different from the cultivars we now grow. The flower on the left is hardly recognizable as a chrysanthemum but the leaves are familiar. It is described as coming from Valencia in Spain but it must have been previously brought there from China by a Spanish explorer and trader. The name chrysanthemum means 'the golden flower' and the early blooms were yellow, like the very small flower illustrated here. They were probably welcomed as providing colour later in the year for the

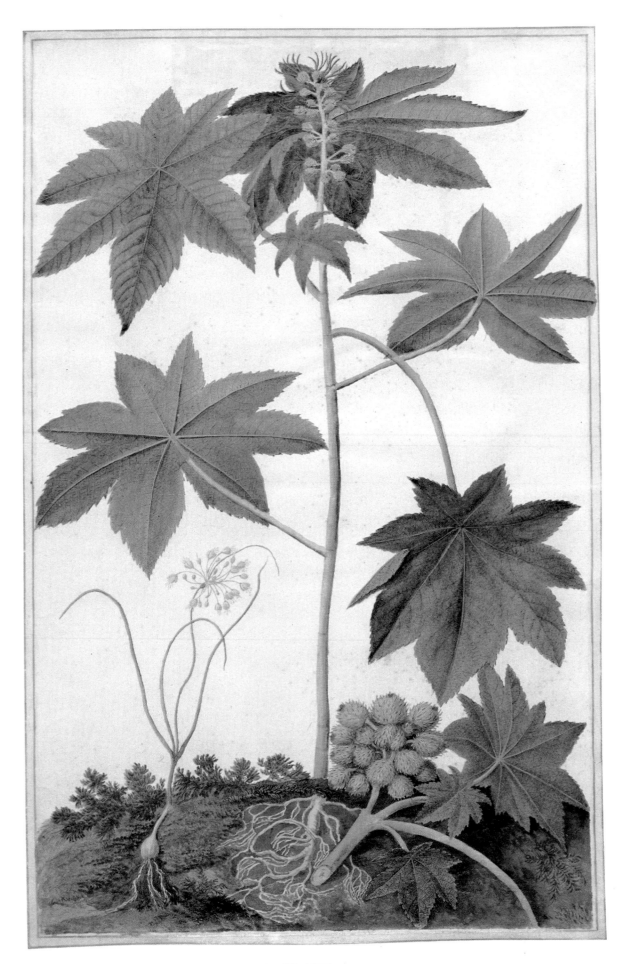

PLATE 15

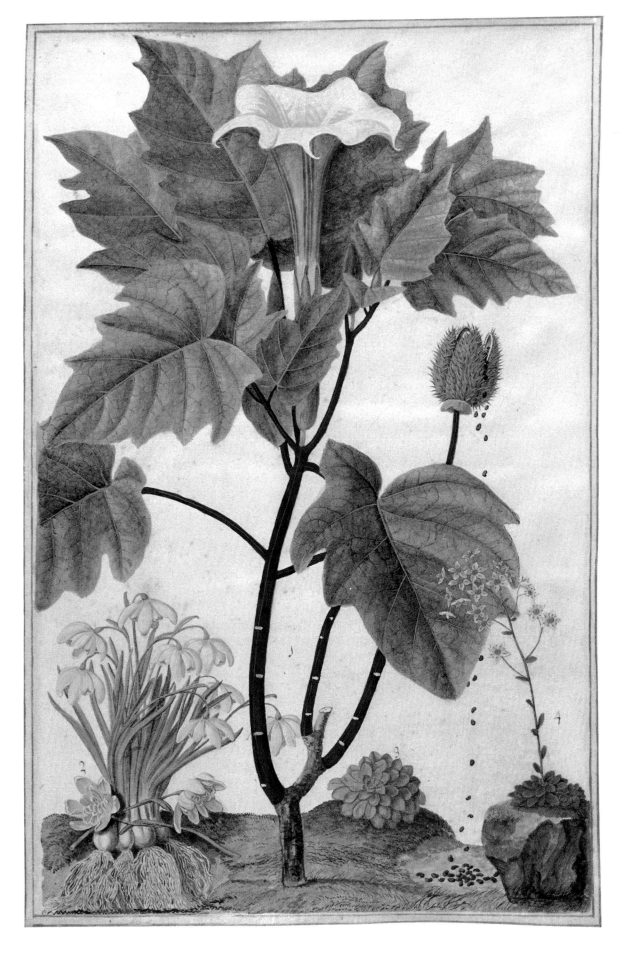

PLATE 16

parterre bed or they may have been grown in pots that could be sheltered from the inclement weather. It was an axiom in the Duchess's day that those interested in 'floriculture' should place their plants either one or three to the pot, in order to establish unity. The theory was that the figure one was complete in itself as was three for it has a beginning, a middle and an end. All other numbers were considered to be irregular and therefore unsatisfactory if one wished to contemplate or enjoy flowers, a curious but interesting conception.

The aster on the right is larger but again a golden colour and takes its name from the Greek for 'a star'. This was one of the flowers brought to Britain from America by John Tradescant the younger in 1633 along with a number of other plants and trees, including the Virginia creeper, red maple, rudbeckia and the tulip tree, all of which provide spectacular and beautiful autumn colours. The later development of asters has produced blooms of pink, mauve, purple, yellow and red, a lovely choice of colour, as, while for the garden parterres at Badminton they would have preferred one colour, we more frequently enjoy mixed colours in our herbaceous borders.

Plate 11

Hyoscyamus, Auricula and Pennycress

Hyoscyamus is depicted in the centre here; the literal translation of its name is 'pig bean' either because pigs eat it or possibly using the word 'pig' in a derogatory sense as 'dog' is used for dog rose or dog daisy. It is of a Mediterranean genus found in districts stretching from the Canary Isles to Central Asia, and belonging to the Solanaceae family. It was formerly cultivated for its medicinal properties, for the whole plant is narcotic and produces an effect similar to that of opium. As a rustic remedy for toothache it was of doubtful value, however, for it often produced convulsions. In the wild it is called henbane and grows in Britain in waste stony places and at roadsides, especially near the sea. Kychicus painted the white one with purple veins here, which he wrote came from Egypt or Sicily, and another yellow one with the same dark centre which came from Crete. The whole plant smells of mice and it is said animals can eat it without harm, so perhaps that is the meaning of pig's or hog's bean. The drug hyoscine derived from this plant

was used by Dr Crippen to poison his wife, an event which goes down in history, as his arrest on board a transatlantic liner was the result of the first use of wireless telegraphy for such a purpose.

The plant on the left is named in the index *Auricula ursi borraginoides*, but its potato-like flower is not at all similar to the modern auriculas, with their white centres and often lace-edged petals which were developed several centuries after Kychicus painted this one. Parkinson described seven types in his 1629 catalogue including the double and cowslip form. There is a very similar flower with blue-purple petals and outstanding yellow anthers in the rock plant *Ramonda pyrenaica* (called now *Ramonda myconi*) but this may have been introduced just after the Duchess's time.

Borraginoides means like a borage plant. Borage is grown as a herb and is also found in the wild but is not considered indigenous to Britain. It also has bright blue flowers and prominent anthers, the juice smells of cucumber and so the leaves are often used for flavouring drinks, although the scent is not strong enough if the soil is too fertile. To quote an old recipe, 'its cordial qualities are good for the heart' and 'the aromatic spikes of flowers should be put into a negus and cool tankards'. Parkinson recorded that the flowers were held in esteem 'to help pains in the head which may happen by a sight of steep places subject to danger'. Gerard also commends them for those who have 'giddinesse and the swimming of the braine' and he calls them 'Beares eares' which seems to explain the middle word of the indexed name *ursi*, a bear.

Thlaspi parvum is the index name of the small plant on the right, which is also described as being of a maritime nature with leaves that are always green. It is commonly called pennycress after the flat seed pods like pennies which remain on the stem in decreasing size until they reach the four-petalled flowers at the top of the spray. Pennycress was formerly used in a medicine known as Mithridate Confection. It is recorded that the seeds of field pennycress were found in the stuffing of an effigy of King Henry III of England, who died in 1272.

Plate 12

Jacea

Jacea is the name given to these three flowers and many others illustrated by Kychicus, all with daisy- or thistle-

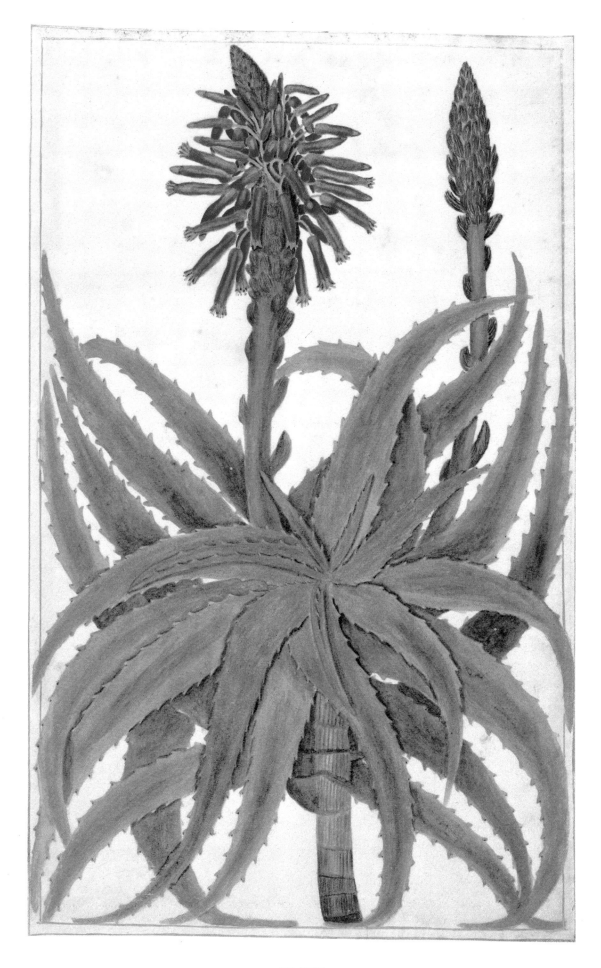

PLATE 17

like blossoms of various colours. A characteristic is the globular head holding the overlapping sepals below the flower head, like knapweed, *Centaurea nigra*, or the blue cornflower, *Centaurea cyanus*. Jacea is a sub-species of Centaureae, a family with many members growing in the wild. The garden types were not introduced until the sixteenth century when they came from southern Europe and western Asia. Gerard mentions that the blue cornflower and also the scabious were coming into gardens in divers sorts that were strangers to England, 'and by cunning do oft times become other colours and some also double'. Those shown here are mauve with differing leaves but some others painted by Kychicus are pink and yellow.

The name *centaurea* comes from the centaur, a creature that was half horse, half human. The centaur Chiron, according to legend, cured a foot injury caused by one of Hercules's poisoned arrows by the use of one of these plants, hence it was called 'centaurea' and has been considered ever since to have healing powers.

The species name *cyanus* applied to cornflowers, bluebottles or bluets involves another ancient fable. A youth called Cyanus was so fond of the flowers that he spent his time gathering them and making garlands for the altar of the goddess of flowers, Flora or Chloris. One day the youth was found dead in the cornfield all dressed in blue, so the Goddess changed him into the flower he loved so much and called it Cyanus. The flowers were used in the past to make a deep blue paint and it seems a pity that the lovely blue colour has become associated nowadays with cyanide of potassium, such a very virulent poison.

The sweet sultan is another member of the Centaureae family. As well as mauve it also comes as a yellow annual, *C. moschata*. Parkinson mentioned in 1629 that it came from Persia and described how it came into cultivation 'because the Great Turk, as we call him,' saw it abroad, liked it and wore it himself and 'all his vassals had it in great regard'. They called it the Sultan's flower – so did Parkinson and so do we.

Plate 13

Melianthus and Crocus

The large serrated leaf and flower in this plate are part of a tree called melianthus, an evergreen from the Cape of Good Hope. The flowers grow in long spikes from the axil of the leaves as depicted by Kychicus and contain a copious supply of honey-like juice, hence the name *mel* for honey and *anthus* a flower or more commonly a honey flower. The honey can be obtained by shaking the branches and drops of it are clearly shown by the artist. The tree was introduced to Britain from Africa in 1688 but it does need some protection here in the winter. *Melianthus major* can reach a height of ten feet but there is also *Melianthus minor*, a honeybush which is a shrub growing only to about two or three feet.

On the right of the painting is a group of the yellow crocus so much loved by the birds, one of the many varieties which grow so profusely in the Mediterranean countries. Gerard calls it the spring saffron and claims it grew wild in meadows in the west of England but Johnson, when he produced the new edition of the *Herball* years later, affirmed that they are only grown in florists' gardens. Gerard says the roots will make a salve to cure gout but they must not be eaten as they 'are very harmful to the stomake', and if eaten, the milk of a cow must be taken or 'Death ensueth'. On the other hand, the autumn crocus *C. sativa* is the mauve flower which provides yellow saffron from its stigmas for use in cooking and formerly for medicinal purposes.

The curiously shaped group on the left is *petasites* with a white flower, but it does not appear to be *P. fragrans*, winter heliotrope, for the cluster is too tight. It is more like the pink butterbur, an indigenous wild flower which blooms early in the year and is followed by very large leaves thriving sometimes in gardens and increasing by thick rhizomes to such an extent that gardeners consider it a pernicious weed. The painting could be of the non-indigenous *Petasites alba* which has smaller leaves and is not so prolific. It was listed by J. Gaertner (1732–91) and would appear to have been a novelty at the time the Duchess grew it.

Plate 14

Polygala and the Blue Convolvulus

Polygala arborea myrtifolia. The description here is so informative that one might assume the Duchess acquired it personally from the plant hunter, especially as it is

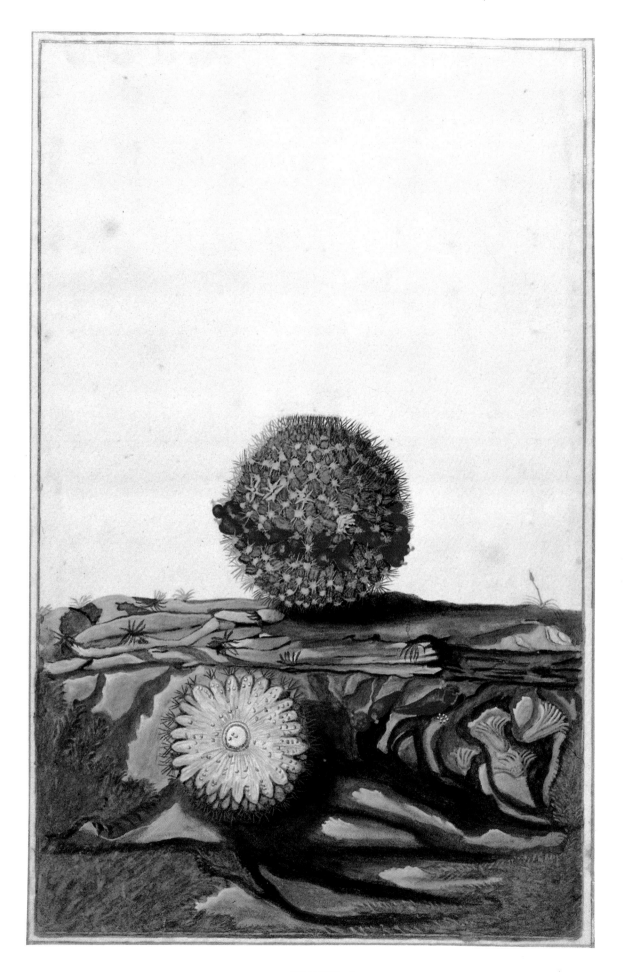

PLATE 18

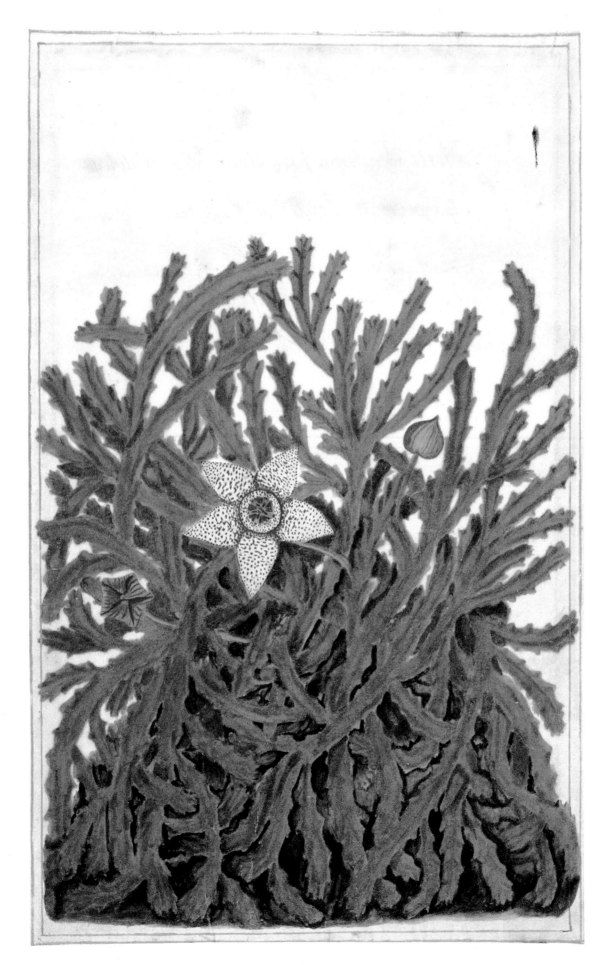

PLATE 19

recorded elsewhere that the plant was introduced in 1707 after these paintings were made. *Arborea myrtifolia* explains that it is a small tree with leaves like those of a myrtle; it came from *Cap bono spei*, the Cape of Good Hope, and had *floribus albus intus purpurea* flowers with a white and purple inside. It is a little like a sweet pea in form.

Polygala is an extensive genus of herbs, shrubs and small trees, some only half-hardy but widely distributed throughout the world, with the exception of New Zealand. The wild polygala which is indigenous to Britain is small, perhaps three to six inches in height growing on grassy hillsides with small blue, pink and white keel-shaped flowers. It is called milkwort, a translation of the old Greek name recorded by Dioscorides, *poly* meaning 'much' and *gala*, 'milk'. It is reputed to promote the secretion of milk but even Gerard did not specify what part of the plant should be used, whether as a draught or a salve, and if for humans or for cows.

Below the polygala there is a group of ipomoea, the blue convolvulus, described on pages 27 and 28 and having here a pale flower, white centred and white lined, and with the usual heart-shaped leaves. The description, in contrast to that of the polygala, is merely 'blue', so the artist has used them to compose a balanced picture and has completed it with the usual roots and a few large stones.

Plate 15

Castor Oil Plant and Allium

Ricinus communis, the castor oil plant, comes from tropical countries where it grows to a height of thirty to forty feet. It was introduced to England in the sixteenth century probably from India, and only grows to about three feet. It is often used as a 'dot' plant in modern bedding schemes, for the foliage is decorative and there are many variants in the colour of the leaves. These have five or seven lobes and are truly peltate, standing on the stem like a shield. Male and female flowers are produced on the same stem growing from the axil of the leaf stem, and making a cluster of fruit as shown in the painting. The seeds are very poisonous and need harvesting with care, for as soon the capsule is ripe it shoots them out in all directions. Nevertheless, it is the seeds which provide

castor oil for medicinal purposes. Castor oil is also of great commercial value in the manufacture of soap, margarine, paints and varnish. It was at one time used as a high altitude lubricant for aircraft engines.

Below the castor oil plant Kychicus has painted one of the alliums showing very thin leaves and an umbel of yellow flowers. Allium is the family name for all the onions, chives, shallots and garlic which frequent the temperate regions particularly in the northern hemisphere, where they spread easily for they produce both bulblets underground and seeds to scatter. In ancient times they were valued for their medicinal and reputed aphrodisiac qualities, in addition to their use as flavouring for food. Gerard recommended that a raw onion be rubbed on a bald head in the sun when 'it bringeth the hair again rapidly'. His advice is to use the onion only as a salve for wounds and a cure for fevers, in fact he says that when eaten they cause headaches, hurt the eyes and provoke overmuch sleep, especially if taken raw.

Plate 16

Datura, Snowdrops and Sedums

The centre flower of this group is the annual *Datura stramonium* or thorn apple, a dramatic and almost regal plant that Kychicus enjoyed painting as it occurs in several of his pictures. Another datura often seen growing in this country is *D. suaveolus*, a paired form with two large white trumpets hanging down, aptly called Angels' Trumpets. The datura are members of a large family with medicinal and narcotic properties, including deadly nightshade, solanums and other poisonous plants as well as potato, capsicum, aubergine and tobacco. The thorn apple produces a fruit which is prickly on the outside, hence its name. It is rather like the horse chestnut fruit but instead of a conker it contains small seeds.

These seeds are profuse and easily produce annual plants which often appear in unexpected places such as waste ground. It quickly became established when introduced into America in 1603 at Jamestown, Virginia, from whence it got its local name Jimsonweed. It was disliked by the Indians because of its rank growth. They associated it with civilization and called it 'the white man's plant'. Gerard claimed to have dispersed it throughout England, along with other rare and strange

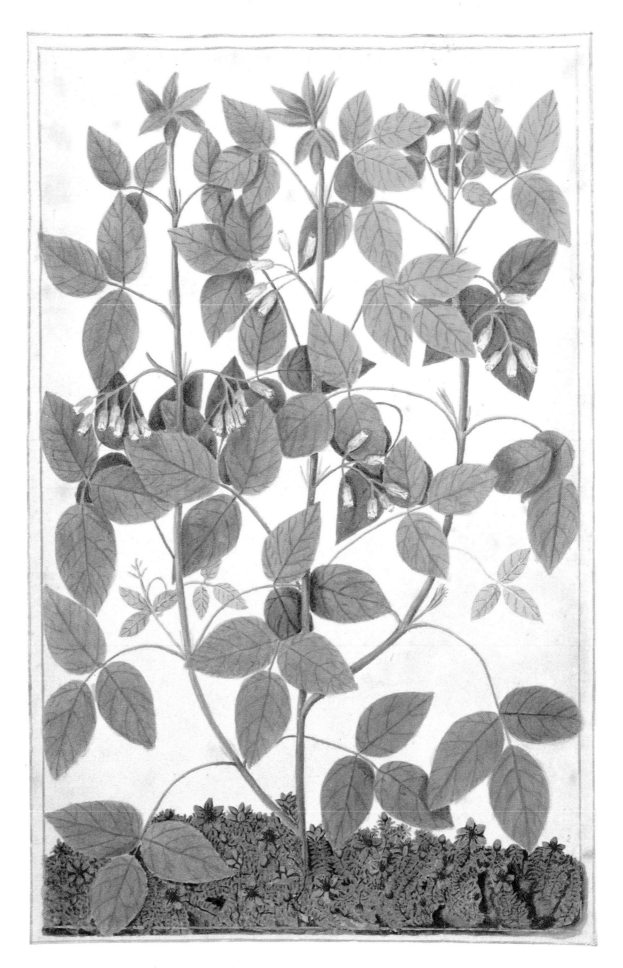

PLATE 20

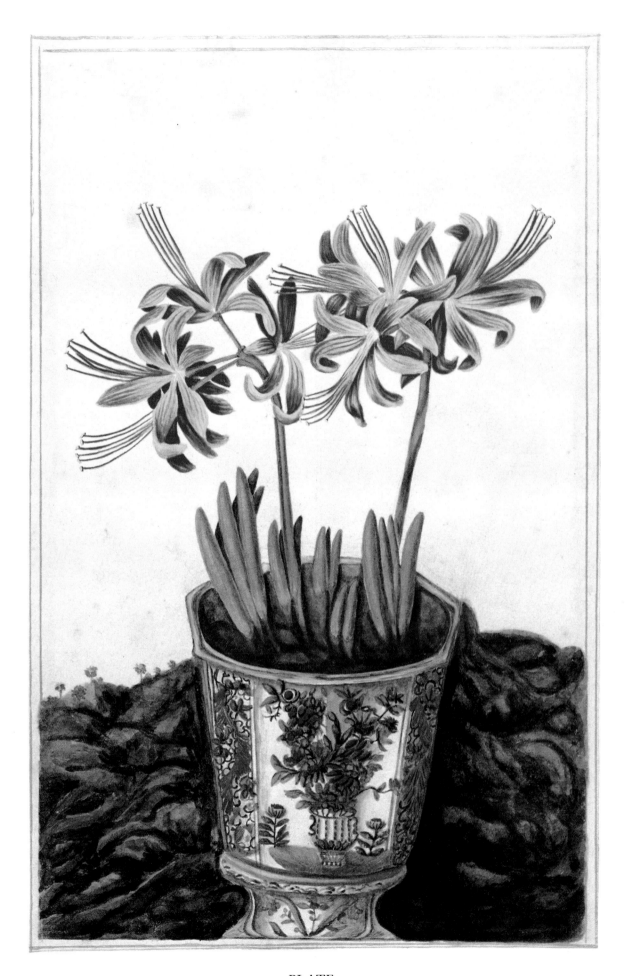

PLATE 21

seeds which he obtained from his friend John Robin, a well-known Parisian horticulturist.

Gerard recommends that the juice of thorn apples be boiled with hog's grease to make a cure for all inflammations and a salve for fresh wounds. He quotes the case of Mistress Lobel, a Colchester merchant's wife, who had been grievously burned by lightning and was perfectly cured by the use of this remedy when all hope was past, as reported by the Notarie of the said town. He does not seem to have appreciated that this can be a very poisonous plant.

If used incautiously, all parts of the plant can be lethal and used in a smaller degree they produce hallucinations and curious paroxysms. Several important alkaloids can be obtained which are used for bronchial and asthmatic complaints. It also produces atropine which dilates the pupil of the eye and is used by oculists when examining the eye and during operations. Even today it continues to be used to make a salve for bruises and burns.

The snowdrop depicted on the left is *Galanthus nivalis*, often called 'the first harbinger of spring' as it is one of the first plants to flower in our gardens. A symbol of hope, tradition asserts that it blooms on 2 February, Candlemas Day, the day that celebrates the Virgin Mary taking the baby Jesus to the Temple, hence 'Fair Maid of February' is another name. The double flower which the artist has painted is not very common but there are bulbs of this variety to be found in Britain which surely should be carefully treasured.

On the right are two sedums, one merely a cluster of succulent leaves and the other in flower. Sedums belong to a large family widely distributed over the northern hemisphere. The majority of the species grow in temperate regions but when they are found in latitudes nearer the equator, they appear on mountain slopes. They have the ability to use cracks in the rocks and to cling to the surface, whether in the rock garden or in the wild. They were known to the Ancients and also to the mediaeval herbalists, but they were not listed until Linnaeus wrote his *Species Plantarum* fifty years after these paintings were completed. Then there were only fifteen known species but now over five hundred have been identified, mainly due to the plant hunters' explorations of Mexico and western China. For this reason it is difficult to decide which species Kychicus has painted, so perhaps it is as well to leave it with his designation – 'Sedum with a white flower'.

Plate 17

Aloe in Flower

There are over a dozen pictures in the manuscripts of the plant aloe, a greenhouse succulent. The one illustrated here was painted by Frankcom who chose to paint the flowering specimens. Those painted by Kychicus were representative of the plants grown from seed which came from the Cape of Good Hope, some still in seedling form.

Wild aloes are shrubby xerophytes which are able to adapt themselves to dry conditions by thickening their leaves to hold reserves of water as does the cactus. The leaves form a rosette around the stem out of which the flowers grow, but some have a stalk or trunk which can reach a height of twenty to thirty feet in their native country. Those the Duchess grew may have come from South Africa, but at a later date they were imported from Abyssinia and Madagascar, where it is said the juice of tree aloes is used medicinally as a purgative.

It is popular as a house plant as the rosettes of thick fleshy leaves are very varied, often with a triangular section and prickles on the margin which may be crowded or few, green, white or yellow. The leaves may have white patches or stripes. The flowering stems may be branched and the flowers can also vary from a drab olive green and yellow to a bright pinkish-orange. They are mostly tubular and clustered rather like a small red hot poker (*Kniphofia*). The one depicted by Frankcom has flowers with a green tip to the orange incurving perianth. Frankom describes it in the index as having a stalk below the rosette, leaves encircling the stem, plain not spotted, and states that he painted it in 1703 and it came from Africa. It comes early in his book so perhaps it was one of his first paintings hence his more than usually detailed note.

Plate 18

Echinocactus

This unusual picture shows examples of flowering plants on a scree or base of rocks, obviously indoors for these are xerophytic plants which only thrive in hot dry climates.

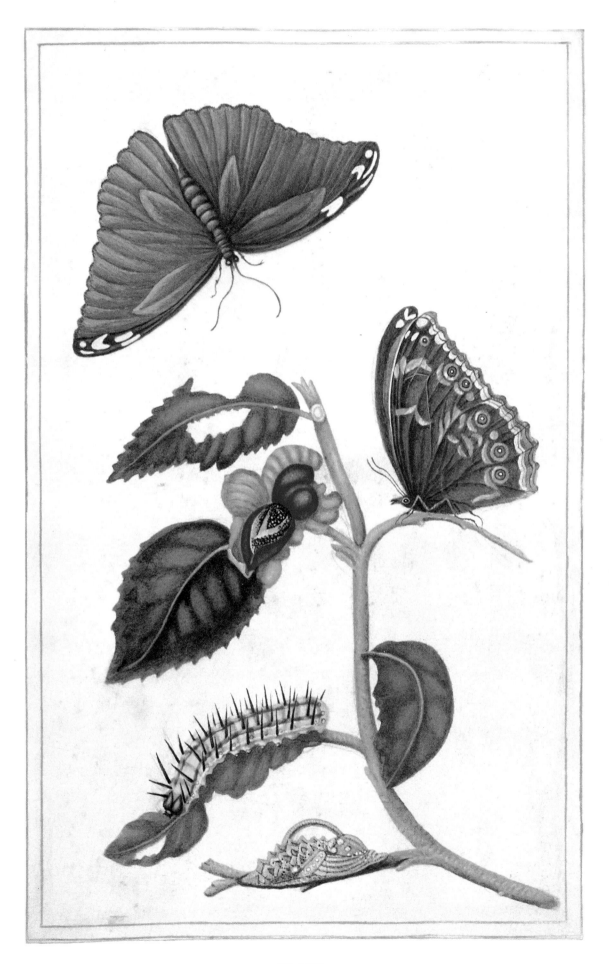

PLATE 22

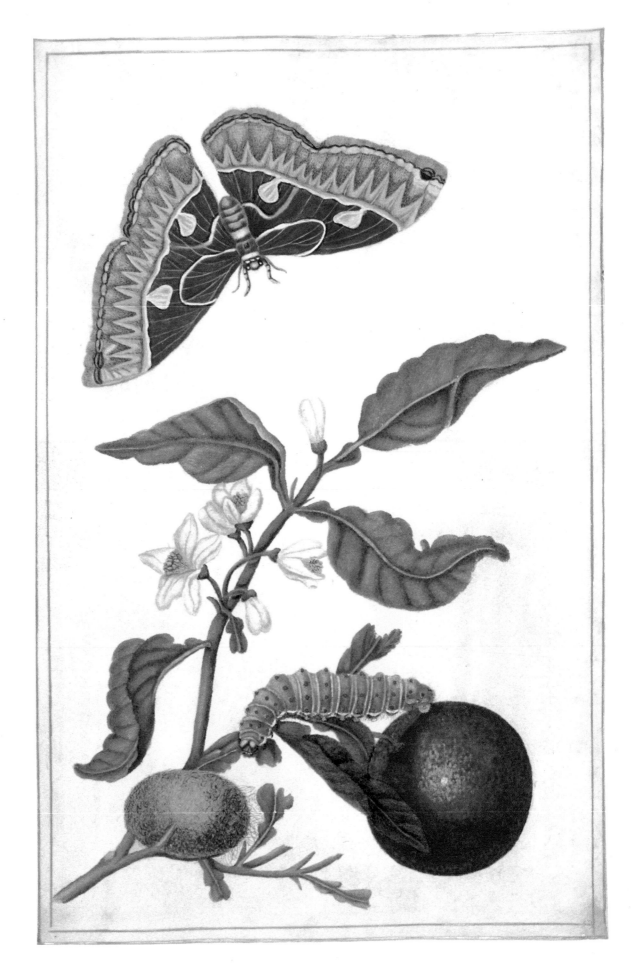

PLATE 23

Echimilocactus is the name given to the round cactus in the centre, probably now called *Echinocactus grusonii*. *Echino* means 'like a hedgehog' which is an apt designation. The spines are numerous and are arranged like white stars with a spacing reminiscent of the geometrical pattern found in fir cones and pineapples. These spines not only protect the plant from animals but have the power of collecting any moisture that may be around and delaying transpiration from the epidermis, the thickened skin of the plant. There are deep ridges which help with the storage of water; the moist milky inside of the plant allows it to live a long time without rain, especially as it is an economical spherical shape. The red flowers and fruits are decoratively arranged around the plant's equator.

The white flower below the cactus is probably another example of a xerophyte in full flower, a daisy-like lithops flower from South Africa. Lithops is a species of Aizoaceae; its name means 'like a stone'. It is indeed difficult to distinguish them from the stones and pebbles among which they grow, especially the marmorata or marbled type.

According to the description written by Frankcom, the small succulents on the right came from America and had milky-white flowers and red pyramid-shaped fruits. Most of the cacti came from tropical America and would have been collectors' pieces in the seventeenth century.

Plate 19

Carrion Plant

Frankcom painted two very different plants which he called apocynum, the cactus-like one in this picture and in another illustration a convolvulus-like plant. Both, however, have the same star-like flowers differing only in size. Apocynum is also known as dogbane, from *apo*, 'away' and *kyon*, 'a dog', in other words 'keep away from dogs as it is poisonous'. All this family have poisonous milky sap but some are treated so that they can be used for emetic and cathartic purposes. The latex of some species has also provided a substitute for rubber when for some reason the latter was not available.

This particular plant is often called the carrion plant, for it has the foetid smell of rotting flesh which nevertheless appears to attract insects. The five-petalled star-like flower is quite characteristic with its green centre and purple-brown spots on pale yellow. The cactus-like leaves are actually thick fleshy stems, four-angled and deeply toothed, with perhaps an incipient leaf on the ends of some. They are found in South Africa as low-growing succulents on sand and need greenhouse protection in Britain. The flower has a curious habit of folding over its petals when an insect alights on it which is clearly seen in the flower on the left of the painting. The insect is trapped and is probably an aid to fertilization as this plant is not recorded as a carnivorous one.

At a later date this species was given the name of *Stapelia* by Linnaeus after a seventeenth-century horticulturist from Amsterdam called Van Stapel, who edited Theocrates' works. It belongs to the genus Asclepiadaceae called after the god of medicine Asclepius, who was generally shown supported by Hygeia, the goddess of wise living and Panakeia, the goddess of cure-alls. It is interesting to note that curative methods of medicine today always advocate good hygiene and sometimes the use of pink pill as a panacea, so the goddesses could still be considered as supports for medicine.

Plate 20

Bladdernut and Snowdown Cushion

The small tree with pendulous white flowers and triple leaves is *Staphylea trifolia* which came from North America in 1640. There is also a staphylea with pinnate leaves which grows in Europe and is illustrated by Frankcom in the picture which follows this one in the manuscript book. This one clearly shows the fruit as a swollen capsule containing a hard seed or nut, which indicates the reason for the name St Anthony's nut or bladdernut.

According to the Doctrine of Signatures, this plant should cure a stone in the bladder. The theory in the Middle Ages was that a cure could be found from a plant that had likeness to the complaint or the part of the body concerned. Thus we have eyebright, lungwort, liverwort, heart's-ease and self-heal. How the capsules of bladdernut were administered is not related but already by the seventeenth century, this theory was distrusted and Parkinson, in this particular case, stated that the plant has no curative power at all.

At the base of the painting is a carpet of green starred with lovely pink flowers, called by Frankcom 'a Snowdown cushion' and which has been painted under that name by both artists. It is said by Frankcom that it was brought by Mr Lloyd. That is interesting for there was a Mr Edward Lloyd (or Llwyd 1660–1709), an antiquary and geologist, who was reputed to be the first Welshman to be a botanist. He climbed Snowdon in 1696 and found the Snowdon lily, which used to be called *Lloydia* after him, and which grows nowhere else nearer than the Alps. The 'Snowdown cushion' in the painting is *Silene acaulis*, moss campion or cushion pink, a plant that grows in crevices in the mountains of northern latitudes and makes a compact tight wad of green with bright pink flowers.

Edward Lloyd had been a keeper of the Ashmolean Museum at Oxford but later became so interested in rocks and fossils that he wrote a book about them in 1699. Presumably he was a visitor to Badminton and would have found many interests in common with the Duchess of Beaufort.

Plate 21

Nerine

Frankcom painted what he called a 'Guernsey Lilly' in a pot. The botanical name is *Nerine sarniensis*, a species of the amaryllis family not the lily family, although the family includes some flowers which look like lilies and bulbous plants such as snowdrops and daffodils.

Nerine is named after the water nymphs of Greek mythology who were the mermaid daughters of the sea-god Nereus, and the bulbs are supposed to have come from the sea around the island of Guernsey. Sarnia is the ancient name for the island, hence *sarniensis*. It was said that the bulbs were cast ashore from a ship that was wrecked on that rocky coast. Some say the ship came from Japan but actually nerines are indigenous to South Africa where they grow wild on Table Mountain. They were brought from that country and given by some ship-wrecked mariners to John de Saumarez, Dean of Guernsey in 1655.

The climate of Guernsey suited them so well that they soon increased and were introduced to the mainland in 1680. The growers in Guernsey have cross bred within the species and through the years have produced colours ranging from the original pink to crimson, orange, blue, magenta and white. Although the Duchess obviously grew them indoors, they do well outside when the conditions are right. If left untouched in a warm well-drained spot, almost before the leaves appear, this striking head of brilliant bloom shoots up in early autumn. They really last quite a long time in the ground or when picked for arranging indoors.

Plate 22

Blue Butterfly

The following five paintings were taken by Frankcom from the pictures of Maria Sibylla Merian and are described by her in her book *Metamorphosis Insectorum Surinamensium*. She was quite an exceptional woman for her time, the first to appreciate the change or metamorphosis of the caterpillar to chrysalis and then to butterfly or moth, and she always painted them in association with the food they needed. She had some considerable inherited artistic ability for her grandfather was a Dutch engraver and her father a Swiss engraver. She would also have been influenced no doubt by her stepfather, a German flower painter, one of whose pupils she married. The enterprising visit to Surinam (Dutch Guiana) was made in 1699 when she was over fifty years old. Her manuscripts are preserved in the Hope Library at Oxford.

Of the lovely blue butterfly on page 43 she wrote:

Sometime ago I was walking in some desert and uncultivated place I found among others a tall Tree which the Inhabitants call the Medlar Tree. In the middle of the Fruit is contain'd a certain whitish Body in Shape resembling a Heart and cover'd with black seeds, which men eat for the Medlar: next under it are 2 thick leaves of a Blood colour, which are follow'd by 5 others of the same thickness but greenish being a sight pleasant enough. Here I found the yellowish Caterpillar streak'd with red the whole length of its Body; it had a dark Head four black prickles in every segment and its feet were of a Rosy colour Having brought it home it chang'd in a short time into an Aurelia of a weedy whitish colour as may be seen

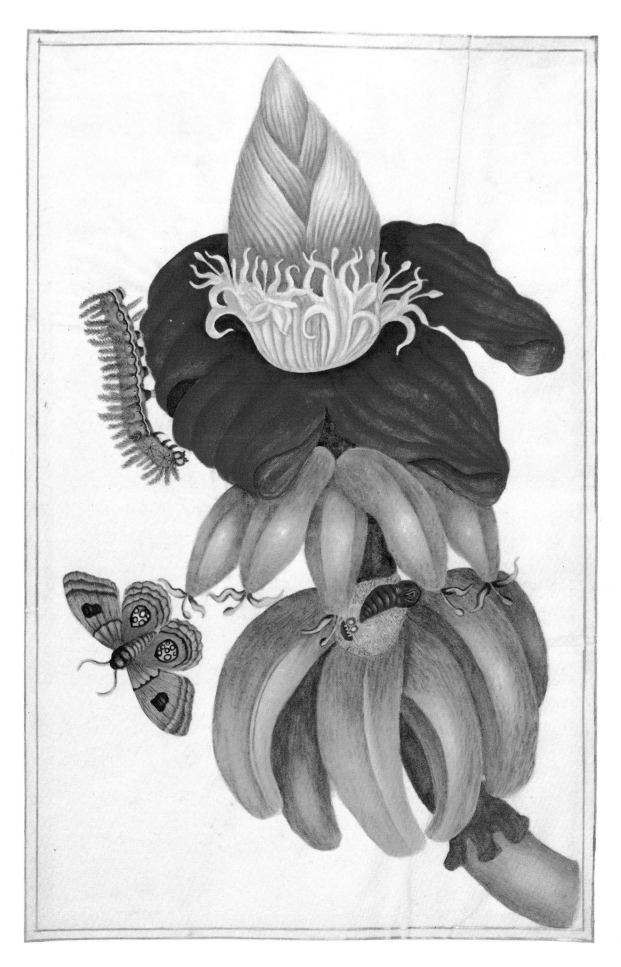

PLATE 24

on the lowermost branch of the Tree 14 days after about the end of Jan 1700 it became the most beautiful Butterfly It rival'd polished silver being of a most bright blew greenish and purple so extraordinary fine that neither Pen can describe nor Pencill imitate its beauty. There are 3 little round spots on each wing of an orange yellow round which are blackish circles again surrounded by a greenish border the outward part of the Wings are of an orange colour prettily mark'd with black and white stripes. The leaves of this Tree are not unlike those that are describ'd for Mespilus Americanus . . . but whether this is the same I dare not afirm being left in the dark by too short a description.

She was cautious but nevertheless M.S. Merian was right for the medlar is named *Mespilus*. Although it may grow in hedges in some parts of England, it is not considered indigenous, but it is common in woods throughout south-eastern Europe and it is from these trees that the cultivated species has been derived. It is, however, *Mespilus germanica* and not *americanus* as suggested by M.S. Merian. Mespilus comes from *meso* meaning half and *pilo* a ball, referring to the flattened apple-like fruit, which is hard and useless until it is beginning to decay – a process called 'bletting' – when it is considered edible by some who have acquired the taste. It is eaten raw but can be made into preserves or wine.

It is not known whether Frankcom had medlars to eat but he certainly copied with great care the pictures of the blue butterfly, also its closed position, the caterpillar and the chrysalis.

Plate 23

Orange Tree

The beautiful butterfly is poised above a spray of the orange tree, *Citrus surantium* showing both flowers and fruit. Some orange trees are known to be over six hundred years old. Not only is the tree long-lived but its origin is so far back that it is unknown, although there are records of its introduction to many different countries. It is now grown throughout the world wherever the climate is suitable.

It is a small evergreen tree with leathery leaves and fragrant white flowers. The large fruit is really a berry, ripening a year after it is formed, and named variously mandarin, tangerine, Seville, Chinese and bergamot. The last-named variety provides an oil used in perfume and all are used for preserves and drinks, both natural and alcoholic. There were Apples of Gold in Solomon's time but they were not oranges for the citrus fruits had not reached Palestine then, but oranges were the Golden Apples of ancient Greek mythology.

The Moors introduced oranges to Europe when they conquered the countries of southern Europe, including Spain, where the story is told of one of the strict rules they made in order to enforce the Muslim faith. On pain of death, no one was allowed to eat an orange or drink its juice unless he had become a true believer.

When the Crusaders returned home they described how they had seen Saracen brides wearing wreaths of orange blossom on their wedding day. It was thought to be a symbol of fertility as the orange tree was so prolific. To this day orange blossom is worn by brides both in Britain and North America, although they may not know the reason.

Plate 24

Banana

This picture is easily recognized as a cluster of bananas with its spectacular flower. M.S. Merian has as usual included the insects which specially enjoy the fruit or nectar of the plant. Her comments on the banana are of interest:

This fruit which is called banana in America serves instead of apples because of its grateful taste and like the Apples in the Low Countrys [from whence she came] is sweet whether boil'd or raw. When it is not full ripe it turns yellow before being white, when ripe it is within and without of a citron colour cover'd with a thick Bark like the Citron Tree. The fruit hangs in clusters and each Tree producing only one cluster which has 9 or 10 Rounds and each of these bears 12 or 14 of the Fruit all looking upwards The cluster is as big as any one man can carry. The Tree has flowers and

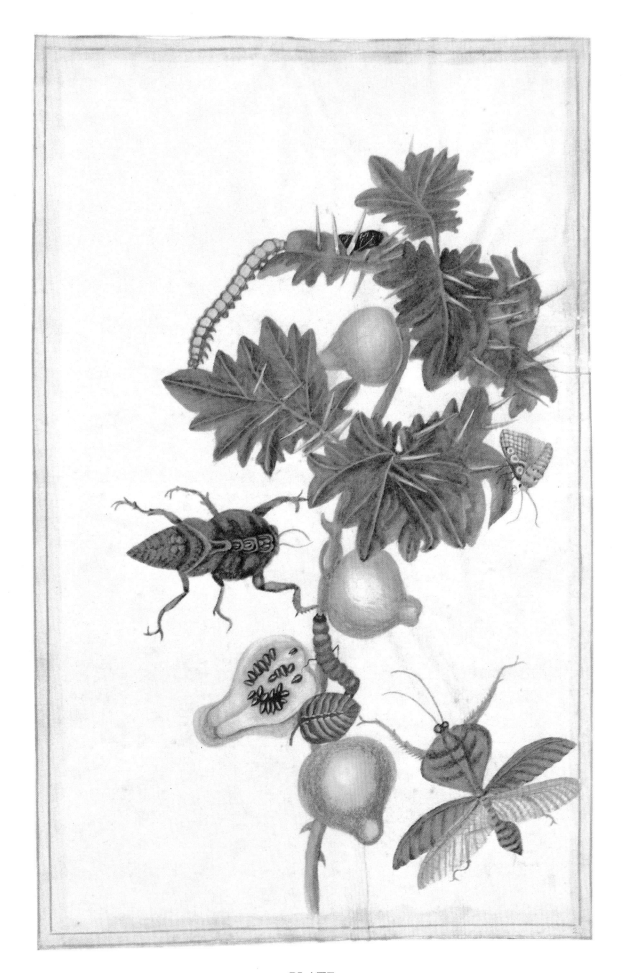

PLATE 25

fruit at the same time, most choice flowers appearing out of the thick leaves like leather of a bloody colour but on the other side cover'd with a sort of blewish dew. The tree is spungy like a cabbage and has a leafy trunk and is composed of severall barks and branches that spring from thence grow in six monthe 13 feet high and thick in proportion like a large Mast of a Ship the leaves above 7 foot long and more than half as broad of a fine green. The Inhabitants put them under Bread that they may more easily put them into Ovens.

Then she describes the insects: 'I found a worm of pale green upon this Tree, with the leaves thereof I sustain'd till 21st Aprill when having cast its skins it became a Nympha, after 10th May it chang'd into this beautiful Butterfly'.

During the seventeenth century, bananas were quite a novelty in Britain. The first bunch to be exhibited in England came from Bermuda and was displayed by Thomas Johnson in his shop at Snow Hill, London in 1633. Johnson had an enterprising, though short, career. Besides being an apothecary, a naturalist, an explorer of mountains, he was a soldier and was killed fighting for the Royalists in the Civil War. He is also known for his very able revision of Gerard's *Herball*, published in 1633, which he amended, adding notes and including more pictures. He must have been one of the many authors who according to Frankcom gave the plant many distinct names, all of which Frankcom wrote that he had collected in his own list under the title of Ficoides – meaning literally like a fig – a word Frankcom used when in doubt for many fruit-forming plants. Amongst the names used for banana were Adam's Apple and *Musa serapinonus* (possibly from the Egyptian god Serapis), the last being nearer to its modern name, a sub-species of *Musa paradisiaca* called *sapientum* or the wise man's banana.

Plate 25

Apples of Sodom

Here is another interesting picture of a plant and its insects painted in Surinam and copied by Frankcom.

Maria Sibylla Merian calls it Apples of Sodom and describes the insects thus:

> The light red Caterpillar with deep red streaks creeping upon the uppermost green leaf I found upon this Plant Sept. 24th 1700. it became a dark colour'd Nympha such as I have describ'd in the same place which Oct 12th chang'd into a yellowish Moth spotted with a dark colour as is likewise drawn sitting on a leaf. The Orange colour'd Worm creeping upon the Stalk was brought to me by a Nigree (sic) slave who inform'd me at the same time that from thence would proceed beautiful Locusts. This was chang'd into a dark colour'd Bulla which by a concurring opinion of the Inhabitants would have been transformed into a green Animacule of this kind which by degrees would have furnish'd with wings like the flying Locusts.

Unfortunately it died, but she assures us the one she has painted is another example of this flying locust.

Maria further describes the plant which she calls Apples of Sodom and tells us they grow to an ell and a half or two ells. (An ell measures 45 inches so it grows to a height of about five to eight feet in the tropical forest of Surinam.) She suggests that Nature put the sharp prickles on the leaves as a warning, for the fruits with dark apple-like seeds are 'Death to Man and Beast'. She then quotes three well-known authorities. Tournefort in his catalogue names it *Solanum americanum* and describes prickly leaves and apple-like fruit. Plukenet calls it *Solanum barbadense* with spiny yet hairy leaves and fruit that is pear-shaped but *inverse* or turned over. Sloane describes it as *Solanum pommiferum*, hairy and with the same inverted pear-shaped fruit. The Solanaceae is a large family and a curious one because it includes the potato, tomato, aubergine and capsicum which are edible as well as some very poisonous plants such as deadly nightshade, *Atropa belladonna*, and plants producing the useful but dangerous drugs of atropine and hyoscyamine.

It is possible that in calling the fruit of this prickly leaved solanum Apples of Sodom, Maria may have known the legendary story brought back by ancient travellers from the Near East. Returning from the neighbourhood of Sodom and Gomorrah, they told of a peculiar fruit supposed to be a symbol of sin and acts as a reminder that God rained fire and brimstone on the wicked people of those two towns (Genesis 19). The reason being that while the apples look good to eat, when they are touched they turn into smoke and ashes. A possible solution to this

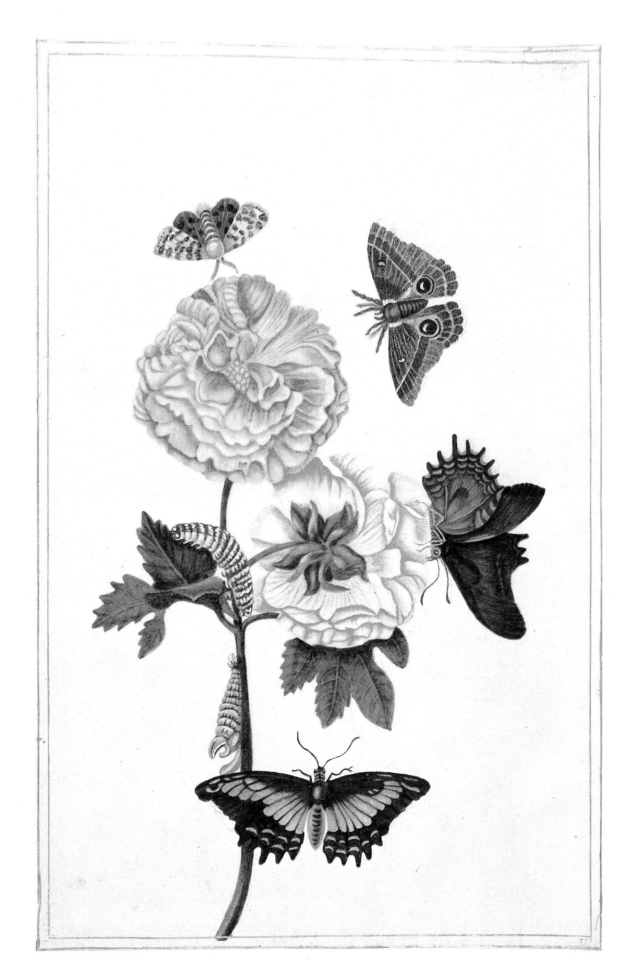

PLATE 26

miracle is that an insect may have eaten the inside of the fruit leaving only the skin intact which, being picked, would crumble to dust. As she was such a keen entomologist this story must have appealed to Maria.

It is interesting to note that there is a shrub called *Solanum Sodomeum* growing on the arid shores of the Dead Sea today which belongs to the nightshade family and is known locally as Apples of Sodom. The fruit looks like a small apple and is very poisonous.

Plate 26

Hibiscus

This is described as a 'double rose' by Frankcom who copied it and the insects from the pictures that Maria Sibylla Merian painted in Surinam. She wrote: 'These Roses were brought from the Caribee Islands to Surinan and thrive there very well. They are white as Snow in the Morning when they open and very red in the Afternnon and fall off in the Evening.'

I found this fine white Caterpillar with Scarlet spots which I placed on the leaf as well as the Roses as of the lesser Lemon Tree. They feed on the green leaves of this bush, with which I nourish'd them from April 26th to 30th, then they stuck fast and became ni'a [nympha] of an Ash colour. Sept 4th 1700 they produc'd Butterflys of 2 kinds. One of which is black and yellow and the other of a dark green on the inside edges of the wings, being the Outside scarlet mark'd with yellow, blew and red spots fined stain'd. In other particulars they are both alike.

There seems to have been some doubt about the identity of this 'rose'. Frankcom quotes two authorities which he respects and with whom he may have come into contact or whose works he must have known: 'This is Rose Sinensis described under that name by Ferrarius in his *Flora Colura*.' There was an Italian botanist, J.B. Ferrari of Siena, who wrote a *Flora* in 1633 and who evidently described a Chinese rose. Frankcom continues 'But with good reason it is called Kelmia sinensis fruito rotundo by Tournefort'. J.P. de Tournefort, who died in 1708, was a

contemporary of Frankcom. He was a celebrated French botanist who devised an early system of plant classification. Without actually seeing this rose Frankcom must have searched far and wide for information about it for he states that he has collected 'all the Names from divers Authors under the Title of *Alcea arborescens Japonica pampineus folys sulasperis flor matabile*'.

He was near the answer, for Alcea or Althaea is a species of the mallow family which includes what we now call the Chinese rose, *Hibiscus rosa-sinensis*. The hibiscus came into this country soon after Frankcom's time. It can have a double flower although it is most easily recognized by the long tube of stamens and stigma standing out prominently from the single flower. *H. rosa-sinensis* makes quite a large tree in the tropics, where the double flower is noted for changing its colour through the day, as depicted in the painting. However, most of the hibiscus species are brightly coloured, particularly in Hawaii where the blossoms are made into garlands or leis which are given to visitors on arrival.

Plate 27

English Insects

Frankcom painted several pictures of British butterflies and moths in their favourite haunts, either as a result of his great interest in those of M.S. Merian or possibly because he had studied entomology before he was introduced to her delightful illustrations.

On the right hand side of this painting will be seen the familiar red admiral butterfly, *Vanessa atalanta*, hovering perhaps in readiness to deposit eggs on the nettles, *Urtica dioica*, which provide food for its larvae. The painting just above shows the underside of the butterfly: legs or claws can be discerned and the rear wings are quite different, brownish-grey with a lighter border. The two dark caterpillars on the nettle especially enjoy eating the seeds; they have light dots on their sides and many bristles or spines. The pupa or chrysalis which can be seen on the left of the nettle is a very light colour with metallic spots and is attached to a leaf by a thin thread. Red admirals may hibernate and reappear during the spring but the majority migrate and arrive back in Britain in June. They enjoy visiting flower gardens, but sadly their numbers

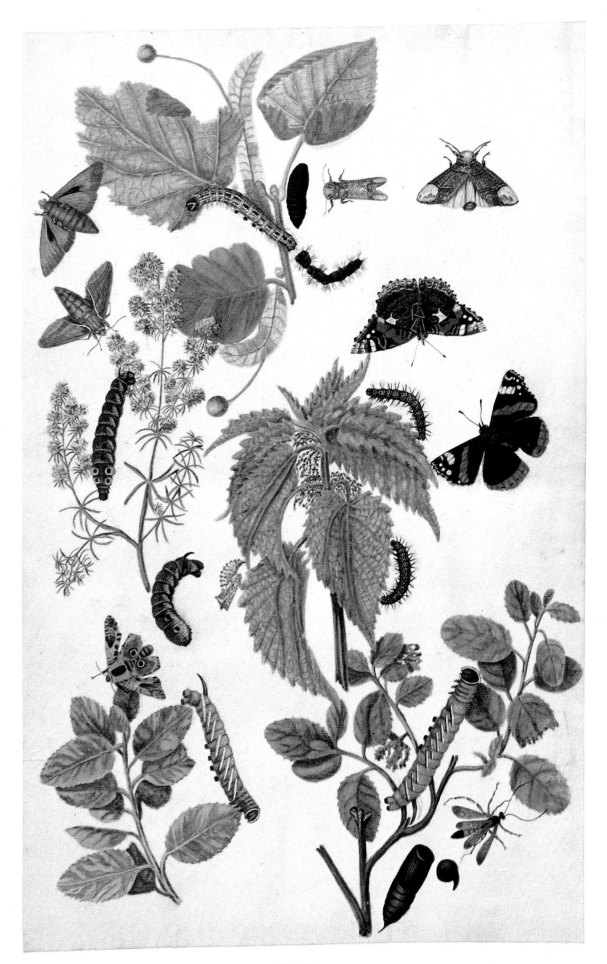

PLATE 27

have fallen in recent years. They suck a drop of nectar from flowers, especially buddleia, verbena, teasels, clover and ivy, and they also enjoy very ripe pears and plums.

With his usual attention to detail, Frankcom shows the caterpillar on the lime branch shedding its skin which it does three or four times as it grows from the larva. The moth at the top right is aptly called the buff tip, *Phalera bucephala*. When at rest, it folds its wings and appears a little like a broken twig hiding its form amongst the deciduous trees which it frequents. The lime branch depicted has a seed on the end of a long stalk supported by the characteristic long pale green bract. The larva has dark spots and yellow lines and the pupa, very dark this time, again hangs from a leaf which it has curled over at the edge. Ladies bedstraw, *Gallium verum*, is the dainty yellow wild flower on the left, over which is a hawk-moth with pinkish-mauve borders to the wings. Frankcom has again depicted the underside, which shows, as usual, a paler pattern – a sort of natural camouflage when viewed from below. Bedstraw or elephant hawk-moths, *Deilephila*, have smooth clearly segmented larvae, with a curious spike, and four small white rings. Hawk-moths have a long proboscis which can reach right down into a flower, even into the tube of a honeysuckle, thereby fertilizing the flower. It is found on flowers mostly at night when the scent is especially strong and attractive.

Below left is another hawk-moth again with a striking form, and suitably named eyed hawk-moth, *Smeranthus osepata*. It is found near buckthorn, alder, poplar and apple trees. The caterpillar has a number of definite oblique white stripes and the pupa is a dark shiny brown, shown here with the head cap off, but not hanging from a leaf because it matures on or under the ground.

Plate 28

Dictamus

The artist has depicted beautifully the delicate veining of the petals and shown clearly the special feature of the very outstanding stamens of this lovely flower head. He names it merely 'fraxinella' which means having pinnate leaves like an ash tree, *fraxinus*. We call it *Dictamus fraxinella*. *Dictamus* comes from the Greek word for the herb origanum or marjoram but it is now given to a family of aromatic plants which include the citrus fruits – lemon,

orange, grapefruit, lime and tangerine. Another pungently scented member of the family is rue, Shakespeare's Herb of Grace.

Dictamus is variously called dittany, gas plant, burning bush, and candle plant because it has glands in the leaves, stem and flowers which secrete aromatic and volatile oils. It is said that on a calm day when the plant is dry, it can be ignited with a match, and for this reason it was considered a sacred plant by the Parsees of India. With its showy racemes growing to about three feet and flowering in June it could have been used to fill in one of the formal beds of the Duchess's garden.

It apparently came to England through Germany in 1596, from traders who had travelled from eastern Europe and Asia. It was recorded by Gerard in his *Herball*. He called it dittany and said that it came from Crete 'an island we call Candie'. He recommended that 'the juice be taken with wine as a remedy against the stinging of serpents'. He also remarked on the smell which 'drives away venomous beasts and doth astonish them'. Because it has the power to cure wounds 'It is very profitable for Chirugians that use the sea and land wars, to carry with them and have in readiness: it draweth forth splinters of wood, bone and such like'.

Plate 29

Sunflower

The large annual sunflower has a botanical name that is an exact description, *Helianthus. Helios* is Greek for sun, and *anthus* is a flower. The flower is said to turn to the sun as the day moves on. The mystic emblem of the Incas, it can be seen as a decoration on ancient Mexican sculpture. It was also the sacred symbol of the Sun God, for Spaniards returning from Peru in 1532 reported seeing the temple handmaidens wearing sunflowers of beaten gold on their breasts and as a headdress. Doubtless the gold was valued more highly by the explorers than the fields of golden sunflowers that they also saw.

The helianthus came to England in Gerard's time at the end of the Elizabethan era. Gerard, who called it Indian Sun or the Golden Floure of Peru, proudly claimed to have grown it to a height of fourteen feet and ever since his time, there have been competitive efforts amongst gardeners to grow the tallest sunflower.

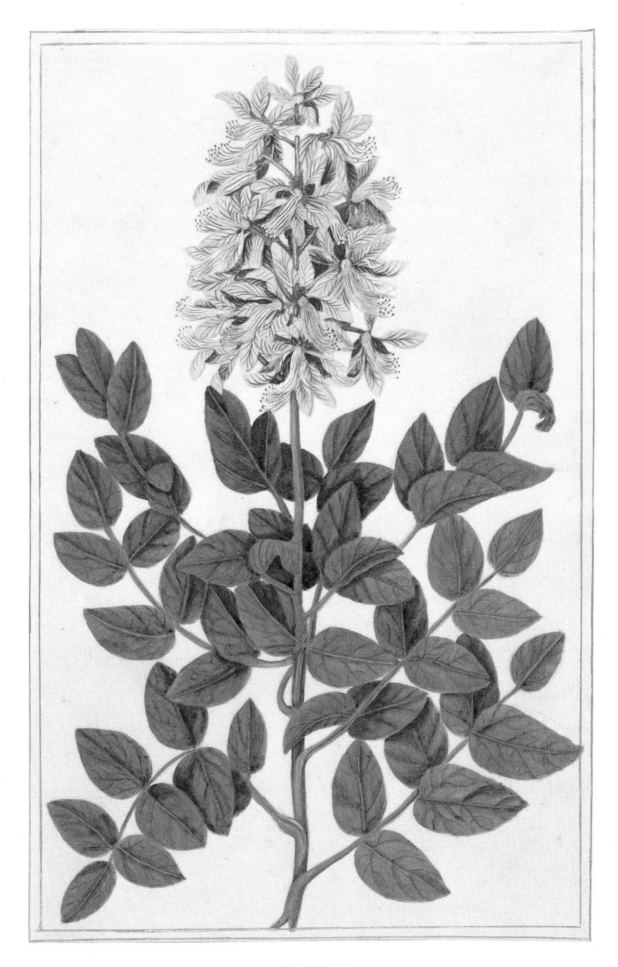

PLATE 28

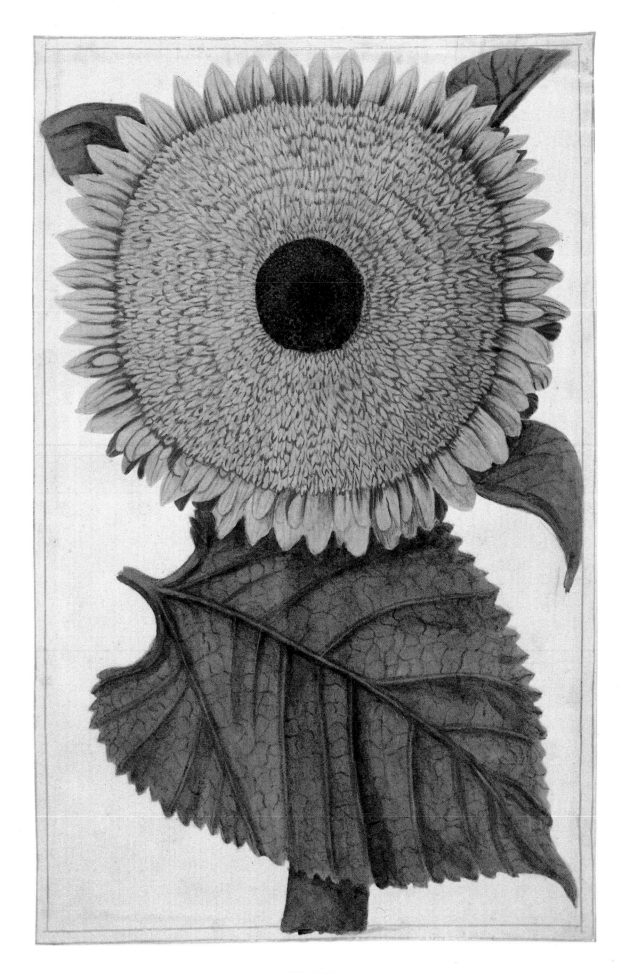

PLATE 29

The leaf clearly painted by the artist is also large, broadly ovate, and can measure up to a foot across. The seeds provide an oil that is used for manufacturing purposes, providing margarine and sunflower oil for cooking, also various forms of cattle food.

Gerard gave a beautiful description of the centre of a sunflower: 'made as it were of unshorn velvet or some curios cloath wrought with the needle, which brave worke if you do thoroughly view and marke well, it seemeth to be an innumerable sort of small floures resembling the nose or noshe of a candlestick.' Here he is cleverly describing the Compositeae family to which the sunflower belongs along with daisies and chrysanthemums. What appears as one flower is really a dense head of closely packed flowers or florets, each of which has one petal and is able to produce one seed. The observant Gerard also views the seeds '. . . set as though a cunning workman had of a purpose placed them in very good order much like the honeycomb of bees'. Here he likens the honeycomb to the spiral formed in the centre of the flower which if closely examined can be seen to grow in both a clockwise and anti-clockwise direction. There is a similarity with the pattern discerned in the fir cone, pineapple, sedum and indeed many plants. This pattern is known to have a mathematical basis related to a series of numbers called after an Italian monk of the thirteenth century, Leonardo Fibonacci. The Fibonacci series is formed by adding adjacent numbers 1.1.2.3.5.8.13, etc. and is used in connection with the golden mean of architecture and the ratio π of a circle. Nineteenth-century mathematicians tried to explain the Fibonacci spirals in plants but we have had to wait for the computer age to show why plants grow in this manner. By making accurate computerized drawings it has been possible to show that the spirals used in nature, and only those, succeed in giving the ideal packing along which the florets grow or the leaf breaks from the stem, in order to receive sunlight with maximum economy. (Robert Dixon, *New Scientist*, December 1981.) Thus the sunflower has taken us all the way from the sacred flowers of the Incas to the scientific age.

Plate 30

Crown Imperial

Frankcom painted two crown imperials, the one illustrated here with a lemon flower and another with an orange flower. This quite unusual plant is never likely to be mistaken for any other member of the lily family for it is rightly named after an imperial crown. At the top of a sturdy stalk is a complete circle of bell-shaped flowers surmounted by a further coronet or tuft of leaves. In the language of flowers it is a symbol of 'majesty and power' and has the modern botanical name *Fritillaria imperialis*. It grows happily on the slopes of the Himalayas and was brought to England with other bulbous plants by traders from the countries of western Asia in 1596, just in time to be included in Gerard's *Herball*. He said it quickly 'made denizens in our London gardens, whereof I have great plenty'. He vividly describes the droplets of nectar which hang from the bells and cannot easily be shaken off, 'drops of clear shining water, in taste like sugar, resembling faire orient pearls', and asserts 'they will never fall away no not if you strike the plant untill it be broken'. It may seem rather an anti-climax to learn after all this that the whole plant 'savor and smell like a fox'.

The crown imperial was popular in Holland and appears in many Dutch flower paintings usually towards the top of the group where the artist generally places the most important flower.

There is a pleasing story about this plant. Legend says that it was originally white with flowers that turned upwards and that it grew with others in the Garden of Gethsemane. When Jesus passed, the other flowers bowed their heads but the crown imperial was too proud. However, on his return Jesus looked so kindly upon the flower that, in dismay, it blushed a bright colour hanging its head in shame and ever afterwards has held tears of sorrow.

Plate 31

Tulip Tree

This painting shows a spray and two flowers of the tulip tree, called 'tulipifera' or wild tulip in the index, now designated *Liriodendron tulipifera*, a member of the magnolia family. *Liro* means lily and *dendron* a tree.

There are three versions of its origin and description in the manuscript, which seems to suggest that it had not been very long in this country. It was in turn likened to maple, alder, poplar and aspen but the descriptions agree that it came from Virginia. The first botanist to catalogue the plants from Virginia was John Ray in his *Historia Plantarum* of 1688, from which Frankcom quotes. The

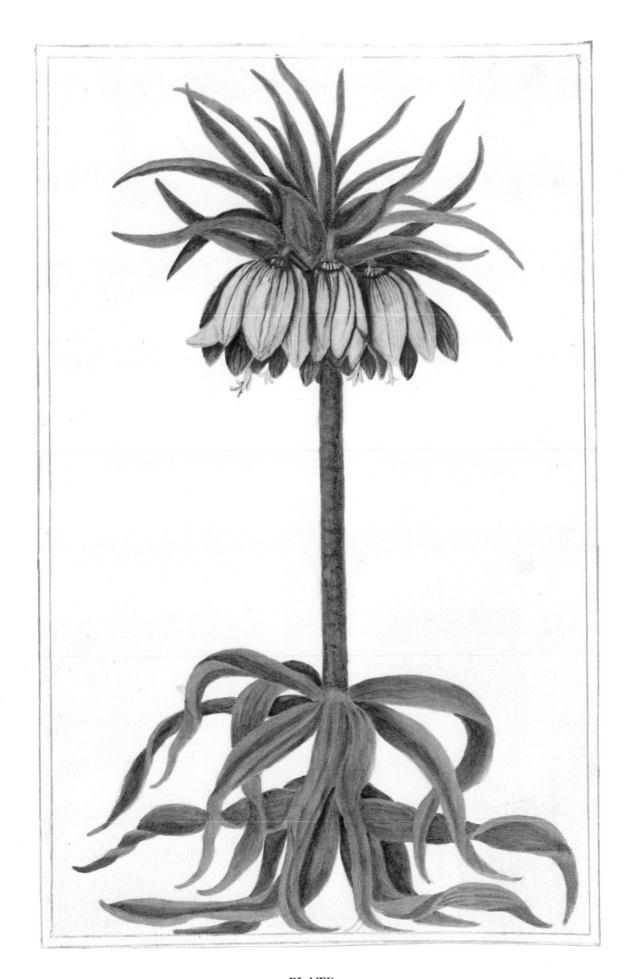

PLATE 30

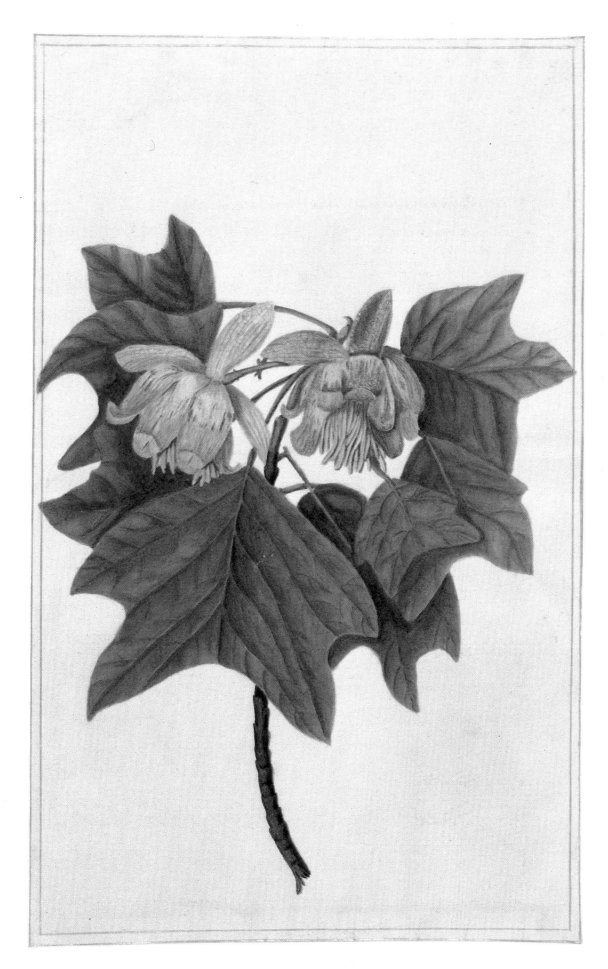

PLATE 31

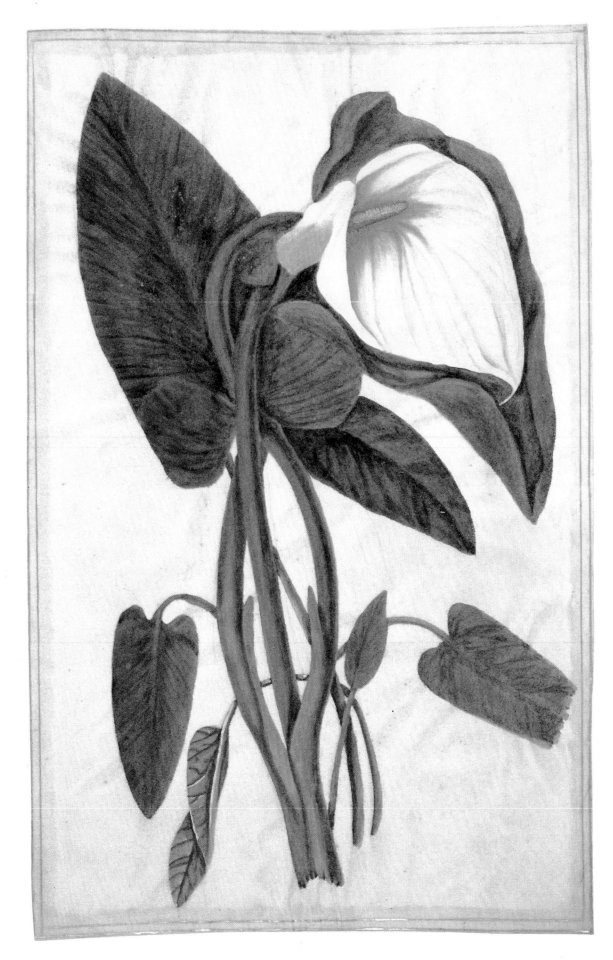

PLATE 32

tulip tree is reputed to have been introduced by John Tradescant the younger along with the red maple, the swamp cypress and the occidental plane from the east coast of North America in the middle of the seventeenth century.

There is no doubt about the similarity to the tulip flower in the yellow blossom growing on the stem. The petals overlap and there are no sepals. The painting shows a very yellow flower with green-tipped petals and green at the centre but it can be greenish-white with yellow or orange markings. The leaves are large and most spectacular, for there are three lobes with the end cut across, almost as if bitten off, which makes it easy to identify this tree. Another of this tree's striking features is its autumn colouring: the leaves turn a brilliant yellow and even in the eastern United States, where the fall colours are so beautiful, this handsome tree stands out as it is not only colourful but can grow to a height of a hundred feet. It is quite hardy but it is doubtful if the first Duchess, or her artists, saw it as other than a small but interesting tree introduced to them from across the ocean.

Plate 32

Arum Lily

This beautiful white bloom is known in Britain as the arum lily and in the United States as the calla lily. Frankcom names it 'Arum from Africa with a sweet scent'. It does not belong to the lily family but to the Araceae. This particular species is now called *Zantedeschia aethiopica* to commemorate an Italian botanist Giovanni Zantedeschi, who lived from 1773 to 1846. *Aethiopica* indicates that it came from Africa where it grows like a weed in hedges and damp places in the south and is even called pig lily using 'pig' in a derogatory sense meaning 'common' as hog and dog are used in Britain. In Britain it can be planted out to bloom in sheltered places in the south, but it is mostly grown as a pot plant in greenhouses, where it usually comes into bloom about Easter-time. For this reason it has become a valued choice for the decoration of churches on Easter Sunday when the purity of the white flower is suitable for the altar and its dramatic shape can be seen from the nave of the church. It should not be confused with the madonna lily *Lilium candidum* which flowers later in the year. This was a

symbol of motherhood for the Ancients so it was chosen by Renaissance artists to typify the purity of the Virgin Mary, especially in paintings which represent the Annunciation.

The arum has an interesting form, for what appears to be a white petal is actually a spathe, a leaf-like structure which enfolds the smooth stem. The flowers, both male and female, are very small and are clustered tightly around the yellow columnal spadix. This construction is also found in the wild arum, the cuckoo-pint of British hedgerows, with its pale green spathe and purple spadix. The cuckoo-pint flower contains some fine bristles which only bend downwards so that insects attracted by the scent are trapped in the bottom where the flowers are fertilized by the insects' movements. The insects are later released when the spathe fades. The plant eventually produces a spike of bright red berries which are poisonous as are the rhizomes unless well boiled. In Shakespeare's time the rhizomes were used to supply a starch to stiffen the courtiers' ruffs, although, according to Gerard, to the detriment of the hands of the laundresses 'for it chappeth, blistereth and maketh the hands rough and rugged and withall smarting'.

There is also a wild arum which grows in North America, *Calla palustris*, having a similar white petal-like spathe but growing only to a height of about ten inches in the rich soil of swamps or along the banks of streams. To quote Dana on wild flowers:

> The first sight of these gleaming white spathes
> across a wet meadow in June and the closer
> inspection of the upright, vigorous little plants
> make an event in the summer. None of our
> aquatics is more curious and interesting, yet
> dainty and pure, than the wild calla.

This description is vividly reminiscent of the sight of some white arums planted in a group in the south of England, equally pure and graceful.

An Alphabeticall Catalogue of all the Plants & Flowers contain'd in this Book

A

Adhatoda Zeylanorum Cat Ley 6 & Pluk 170
Alcea maxima
Allium tenui fol bicorna lat C Bauh Pag 41
Aloe Afric caul fol glauc caulem amplect spinos Comm 19
Aloe Afric caul fol glauc caulem amplect denso spinos Comm 20
Aloe Afric humilis fol ex albo & viridi variegato Comm Quate printed 1702 fig 20
Aloe Afric triangulo longifs & angust flor luteis foetidis Comm Amst Vol 1 Tab 15
Aloe Algiana fol viridi
Aloe Guineensis radice geniculata folys viridi & exis undulatim variegatis Comm &c
Aloe caul of Seed from the Cape of good Hope
Aloe a Seedling
three Seedling Aloes
One Aloe with a turning Leaf
A low Aloe
Althea lutea Plant C. 6
Amaranthus globosus Amst Vol 1 46 Bux 21
Apocynum Americanum Chamaenerii folys Ham Par Bat 10 Pluk 241 2
Apocynum rectum elatius salice angusto fol Pluk 139 2
Anundinacea spinosa Park 1645
Asparagus aculeis recurrentibus fructu from the Streights of Magellane Asparag
Zeylanica &c Cat Ley pag 640 Hort Mal Vol 10 pag 10 Philosoph Transact Vol 20 pag 710
Asphodelus minor flore albo folio fistuloso Chabraei Stirp pag 441
Aster sugeros conyzoid Africanus Pluk 131 12
Gript Auriculas
Auricula ursa Boraginoides Munt 110

B

Balsamina cucumerina folio amplo flore candido fructu Hort Mal T. 10 Tab 16
Blattaria sive Verbascum lusitanicum flore luteo ample H Sept 1652
Blattaria sive Verbascum H Sept 1645 & Dec 1645
Bulb

C

Carduus
Carduus sphaerocephalus acutus major Pluk 373 2
Carduus sphaerocephalus acutus minor Pluk 373 1
Carduus tomentosus Acanthium dictus Arabicus Pluk 1645
Carduus with a white flower
Catanance H Sept 1652
Cereus Amst Vol 10 103
Cereus minima serpens Amer Pluk 130 2
Cereus pyramis Amer Park 1600 Herm 115
Chamaeleon niger alt Lucet 607
Chondrilla prior legitima Dioscoridis Pluk 701
Chrysanthemum Pluk 225
Chrysanthemum Zeilanicum Asse Lobel Obs 246
Clematis from the Cape Baccifera folium laurus Alexandrina simili flore albo odorato



Clematis pasflora Munt 162
Clematis pasflora pentaphylla flore caerulee punctate Munt 163
Clematis pasflora trifolia flore Rose Munt 162 Plum 66
Winter berry Climber Hort Mal P 5 Tab 27
Convolvulus albo minimo Lobel Obs pag 348
Convolvulus blue
Convolvulus coccineus folio angusto &c Pluk 324 2 Comm Amst 6
Convolvulus siculus flo caerulee minimo Munt fig 130
Cous monspuliensum Tarfa 672 2 Advers pag 174 Lobel Observat
Cotyledon H 10 m 1
Cotyledon Park 740 2
Cymbalaria Italica Park 602
Cynoglossum maximum montanum Park 512 & Mor Vol 3 Tab 2

D

Dens caninus flore purpurante Park Parad pag 191 fig 7

E

Euphorbium sive Tithymalus Aizoides fruticosus Canariensis
Quadrangularis &c Comm Amst Vol 3 fig 104
Euphorbium Tithymalus aiz Afric simpl Comm fig 7

F

Ficoides
Ficoides
Ficoides
Ficoides
Ficoides
Ficoides
Ficoides alsine pusilla Bocc 40
Ficoides sive Chrysanthemum aizoides Africanum triangulari folio flore aureo
Bryn Tab 01
Ficoides erecta tenui folia flore albo Herm Parad Bat pag 160
Ficoides flore rubro
Ficoides folio magno flo pleno albo
Ficoides frutex minor spinosa
Ficoides frutex minor spinosa
Ficoides maximus Brun 00
Ficoides mesocaulos mamillaris glabra Pluk 291 Herm Par Bat 156
Ficoides minima

An Alphabeticall Catalogue of all the Plants & Flowers
contain'd in this Book.

An Index page from the original book of paintings
by Daniel Frankcom

BIBLIOGRAPHY

Coats, Alice M., *The Treasury of Flowers*, Phaidon, Oxford, 1975.

Dana, Mrs William Starr, *How to Know the Wild Flowers*, Dover, New York, 1963.

Johns, C. A., *Flowers of the Field*, ed. G. S. de Boulger, Sheldon Press, London, 1925.

Johnson, A. T. & H. A. Smith, *Plant Names Simplified*, Landsman Books, Bromyard, Hereford, 1972.

Johnson, George W., *Gardeners' Dictionary*, George Bell & Sons, London, 1875.

Johnson, Thomas, *Gerard's Herball 1634*, ed. Marcus Woodward, Spring Books, London, 1927.

Keble Martin, W., *The Concise British Flora in Colour*, Michael Joseph & Ebury Press, London, 1965.

Lehner, Ernst & Johanna, *Folklore & Symbolism of Flowers, Plants & Trees*, Tudor Publishing Co, New York, 1960.

McClintock, David, *Companion to Flowers*, G. Bell & Sons, London, 1966.

Nicholson, George, *An Illustrated Dictionary of Gardening*, L. Upcott Gill, Strand, London, 1885.

Novak, F. A., ed. J. G. Barton, *The Pictorial Encyclopedia of Plants & Flowers*, Paul Hamlyn, New York, 1966.

Perry, Frances, *Flowers of the World*, Hamlyn, London, 1972.

Phillips, Henry, *Flora Historica*, E. Lloyd & Son, Harley St, London, 1824.

Praeger, R., 'The Genus Sedum', *Royal Horticultural Society Journal*, May 1921.

Stearn, William T., *A. Gardener's Dictionary of Plant Names*, Cassell, London, 1971.